IMAGES
of America

SARATOGA SPRINGS
A HISTORICAL PORTRAIT

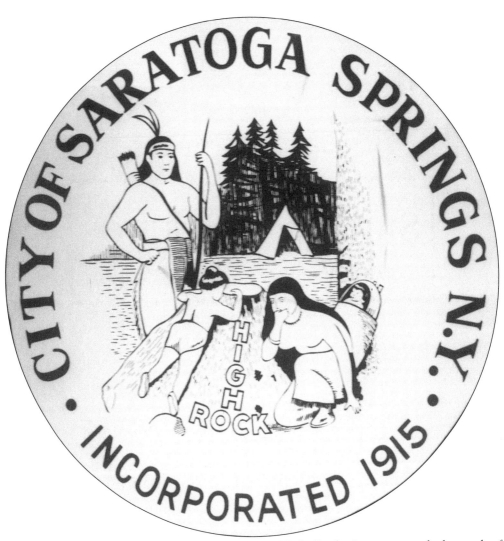

This scene depicts a Mohawk family visiting High Rock Spring toward the end of the 19th century.

IMAGES
of America

SARATOGA SPRINGS
A HISTORICAL PORTRAIT

Timothy A. Holmes and Martha Stonequist

ARCADIA

First printed in 2000.

Published by Arcadia Publishing,
an imprint of Tempus Publishing, Inc.
2 Cumberland Street
Charleston, SC 29401

Printed in Great Britain.

Library of Congress Catalog Card Number: 00-106499

For all general information contact Arcadia Publishing at:
Telephone 843-853-2070
Fax 843-853-0044
E-Mail sales@arcadiapublishing.com

For customer service and orders:
Toll-Free 1-888-313-2665

Visit us on the internet at http://www.arcadiapublishing.com

CONTENTS

ACKNOWLEDGMENTS

Thanks for invaluable assistance go to the Saratoga Springs historian's office; the directors and staff at the Historical Society of Saratoga Springs, Brookside Saratoga County Historical Society, the Saratoga Room at the Saratoga Springs Public Library, and the Saratoga Springs Urban Heritage Program and Visitors Center; Richard Beresford; Elizabeth Smith; Anne Palamountain and Skidmore College; and Yaddo.

INTRODUCTION

The Medicine Springs of the Great Spirit were known to native peoples for countless generations. The springs are set in thick forests just 10 miles from a long river valley, part of a great rift in the earth, and in the foothills of an ancient mountain range. They are centered in a rich region encompassing just over 40 miles to the north and south and nearly 30 miles to the east and west. The natives called this region *Serachtague,* or "place of the swift water," referring to what was later called Hudson's river.

Along the river and in the lakes to the north, the countryside began to stir with the ambitions of newcomers. To the land of the Iroquois Confederacy came the French, the Dutch, and then the English. From the early 1600s, for almost 200 years, these powers struggled for supremacy over the wilderness, the challenging climate, and each other. In 1776 and 1777, the American Revolution changed all. Less than 20 years before, the bubbling waters had been revealed to a venerated settler, Sir William Johnson, who marveled at their extraordinary curative qualities. Even before the Battles of Saratoga in October 1777, interest in the springs had attracted the area's first cabin. By 1883, Philip Schuyler had cut a bridle path inland from his family estates on the Hudson. An early visitor was George Washington, on a tour to inspect northern defenses, who sought to acquire the singular site.

The springs of Saratoga were never again neglected. They soon became the source of continual summers of health and recreation. Over time, they became a legendary attraction. In 1819, a township was established and, in 1915, the city of Saratoga Springs was incorporated. To the friends who came to be a part of it, the vibrant life was and is the most important thing.

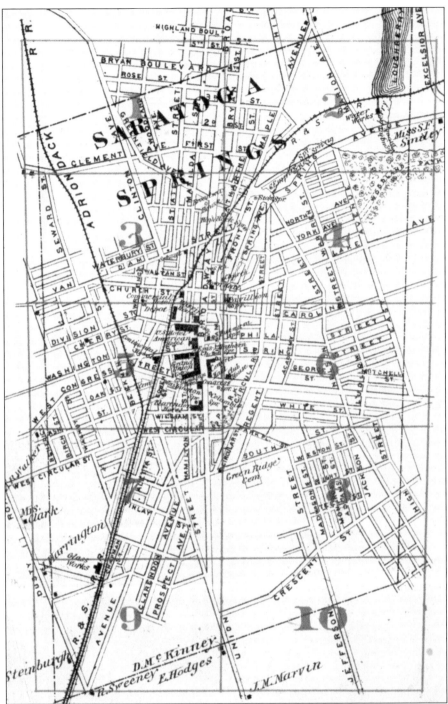

Saratoga Springs sits in the center of Saratoga County. It was incorporated as a city in 1915, after more than 100 years of success as a popular summer resort. Less than 30 miles to the south is Albany, the state capital. Ten miles to the east is the Hudson River. Saratoga Springs is 200 miles distant from both New York City and Montreal. Its location in the foothills of the Adirondacks has made Saratoga a crossroads in history and in leisure.

One

THE FOUNTAIN OF YOUTH

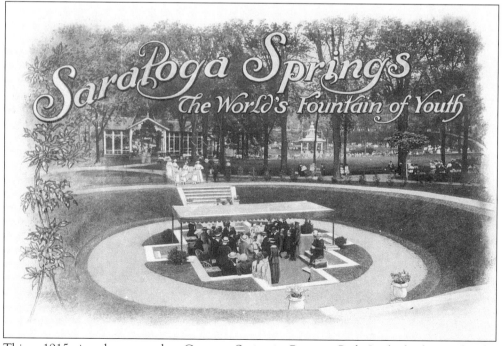

This *c.* 1915 view shows a sunken Congress Spring in Congress Park. In the background is the Victorian bandstand.

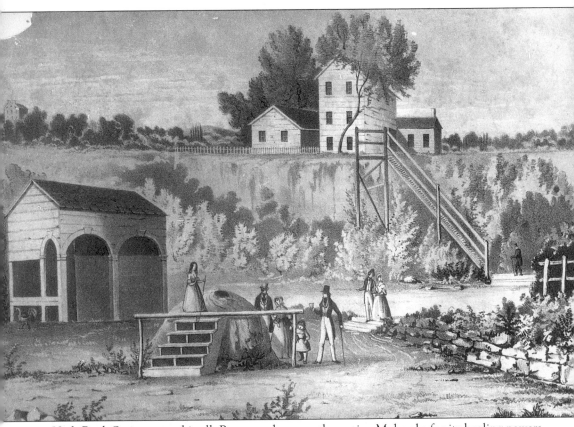

High Rock Spring started it all. Renowned among the native Mohawks for its healing powers, the spring was revealed to the Indians' beloved Sir William Johnson in 1771. Superintendent for Indian Affairs under King George III, Johnson reported the discovery to his friend Philip Schuyler, who was then breaking ground on 4,000 acres on the Hudson River to build a village known as Saratoga. Schuyler established a road to the solitary spring in the swamp. The spring emanates from the large cone at which the dipper girl stands.

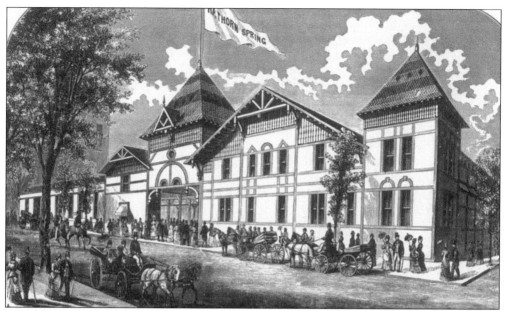

One of the best-developed and promoted springs was the Hathorn, containing a rich mixture of minerals. Through the1800s, it catered to the fashionable who flocked to Saratoga from the big cities in the summer season. This view dates from the 1890s.

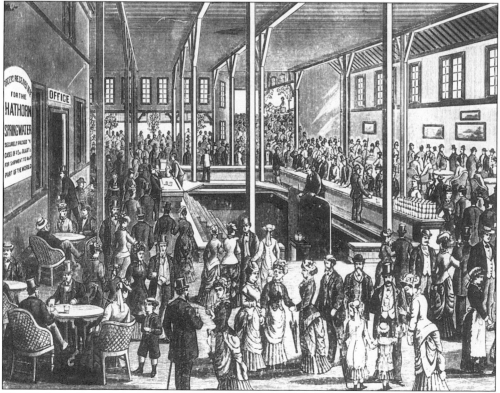

The Hathorn Spring's location was just a block from Broadway, and the great hotels helped to make it a popular meeting place.

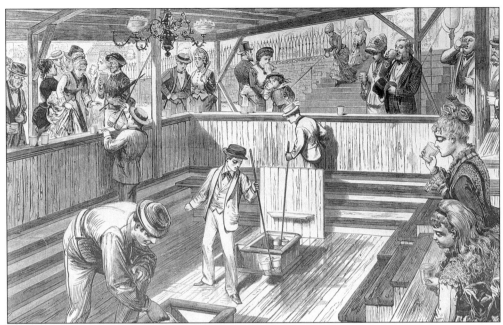

Healing waters had the endorsement of the medical community as a leading curative. The mystique was enhanced by a somewhat solemn serving ritual.

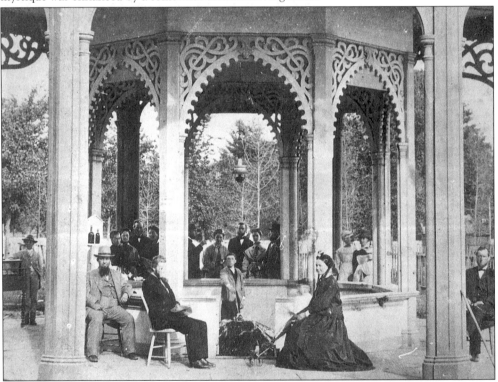

For respectable Victorians, High Rock Spring had evolved into a very proper place to be. Ornate buildings added comfort and dignity, far different from the bare cone known to Philip Schuyler and George Washington, who had offered to purchase the location in 1783.

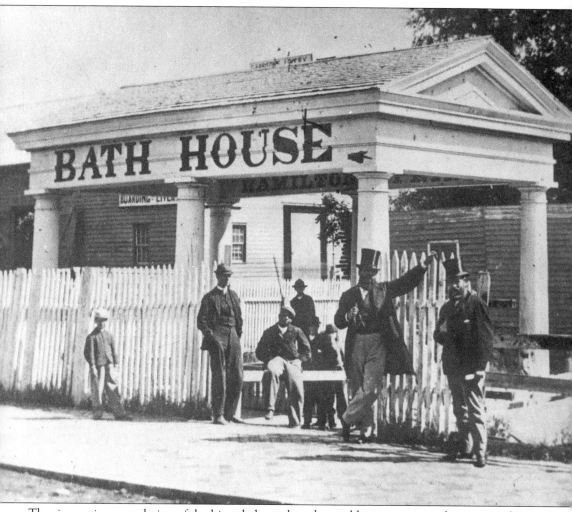

The increasing popularity of bathing led to the pleasurable experience of enjoying the stimulating effects of the bubbling waters in full immersion. The Hamilton stood at Spring and Putnam Streets, one block from Broadway.

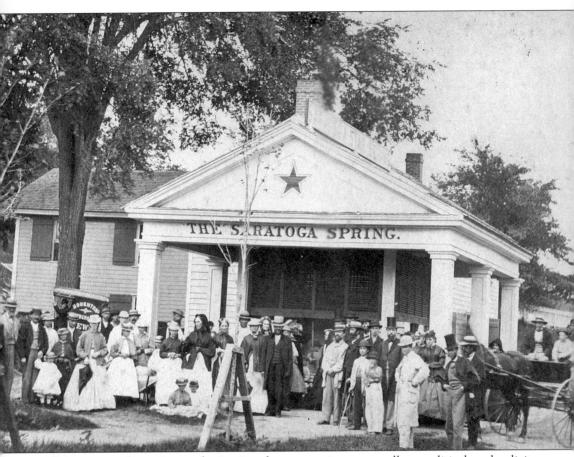

THE SARATOGA SPRING.

Saratoga was becoming a destination for conventions, as well as political and religious meetings. The springs added a wholesome purpose for many. This group has stopped at the Star Spring.

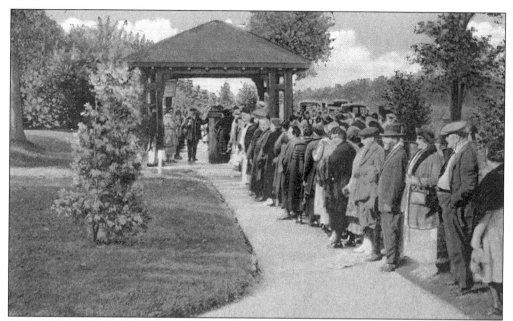

After 1900, with the elaborate Victorian structures diminished, legendary springs still drew a crowd. Below, bottling operations flourished, as the value of drinking healthy water became a national trend.

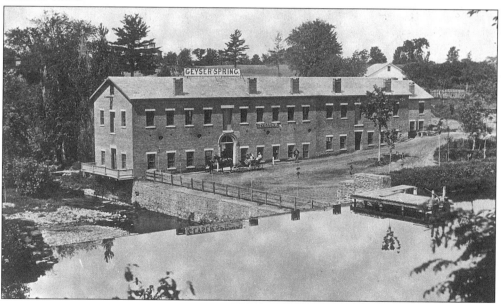

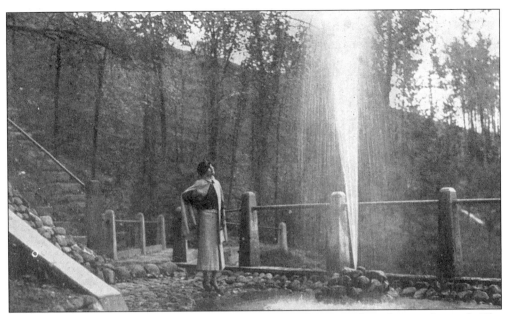

The Spouting Spring added an element of fascination to the waters from deep in the earth. The establishment of the New York State Reservation led to the maintenance and promotion of some popular springs and entertainment facilities into the future.

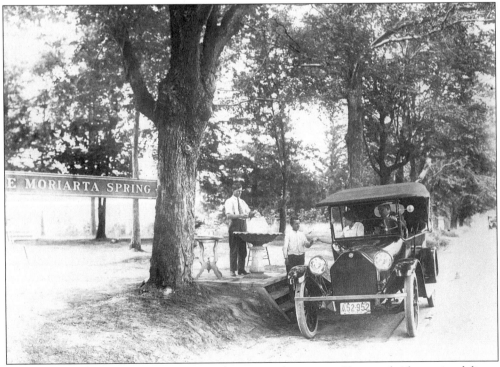

As modes of travel changed, convenience kept up with progress. Here, curbside service delivers the same great product.

No expense was spared in putting the latest technology to work for the village residents.

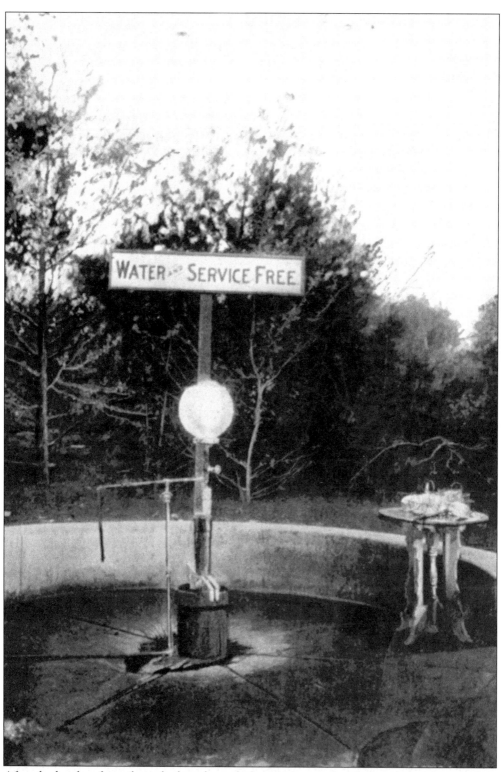

After the height of popularity had moderated, the springs continued yeoman service.

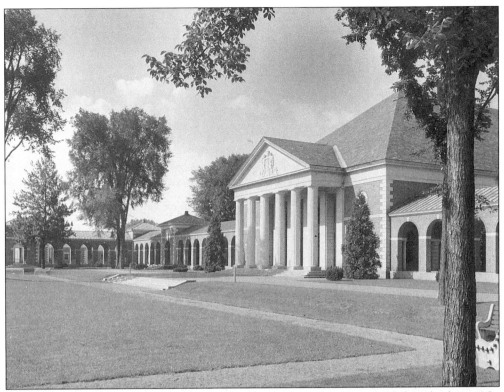

"In this favored spot spring waters of life that heal the maladies of man and cheer his heart." So reads the inscription over an arcade to the Hall of Springs at the Spa. Here, uses of the rare naturally carbonated waters were studied in a laboratory named in honor of Dr. Simon Baruch, who had worked to bring about a European-style spa in Saratoga. The laboratory and the buildings were funded by his son, the financial genius Bernard Baruch.

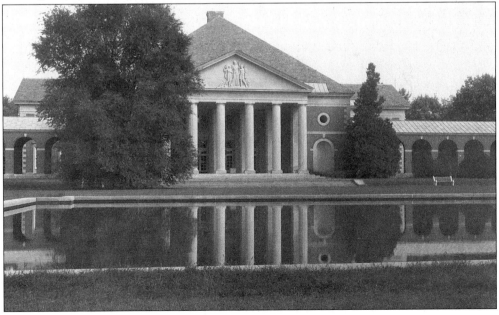

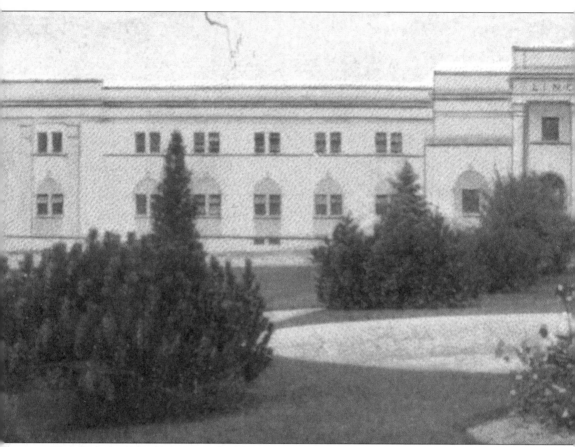

The Spa also hosted majestic bathhouses for the pleasure and resuscitation of visitors to Saratoga. The stimulating and relaxing waters proved their enduring value in treating chronic

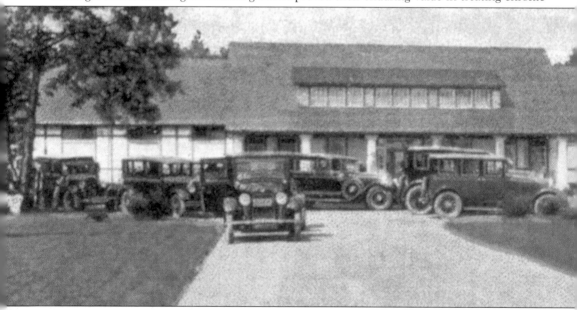

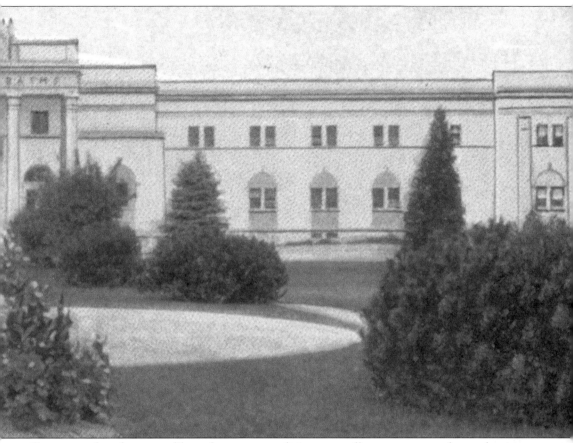

illnesses, such as heart trouble and nervous conditions, as well as temporary aches and pains. Above are the Lincoln Baths and, below, the Washington Baths.

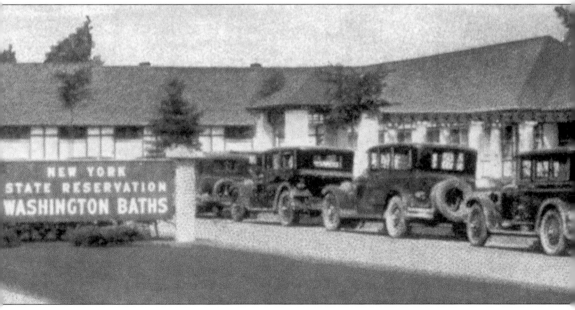

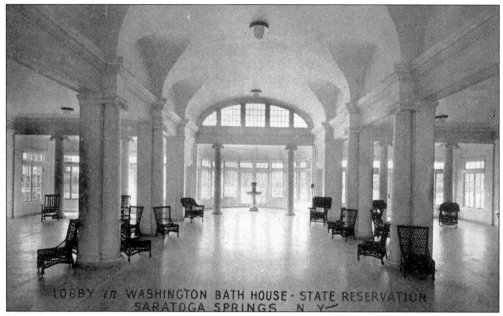

The clean and elegant surroundings put patrons at ease in a classic setting. This spirit has continuously represented Saratoga as a place of leisure, pleasure, and good times.

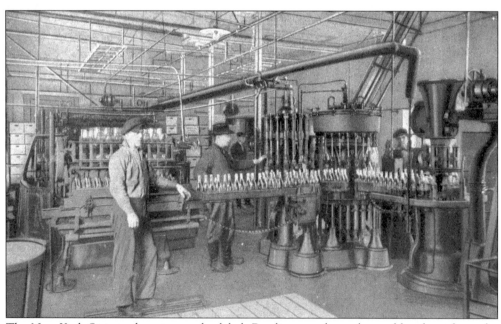

The New York State seal was a popular label. Bottling put the seal on tables throughout the town and country, helping to make Saratoga's name synonymous with good water.

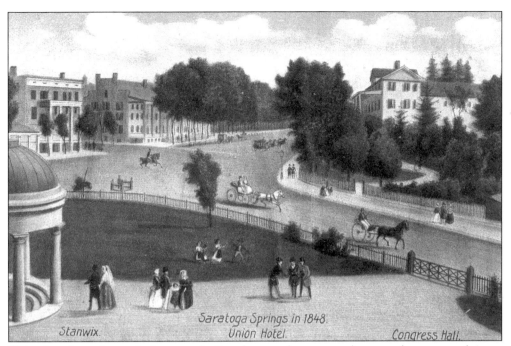

This view from the park shows early Broadway—what was to become the center of town. Columbian Spring is on the left.

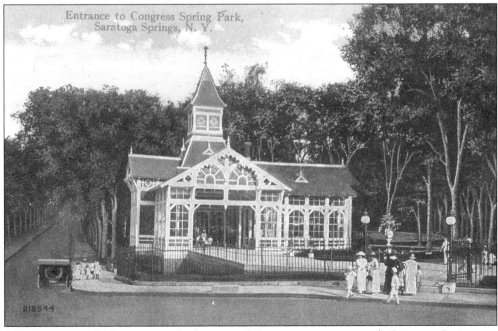

Congress Spring Park was named after one of the springs it contained. Congress Spring was discovered in 1792 by Sen. Nicholas Gilman. By 1803, Gideon Putnam had built a substantial guest house and the annual pilgrimage of visitors was on.

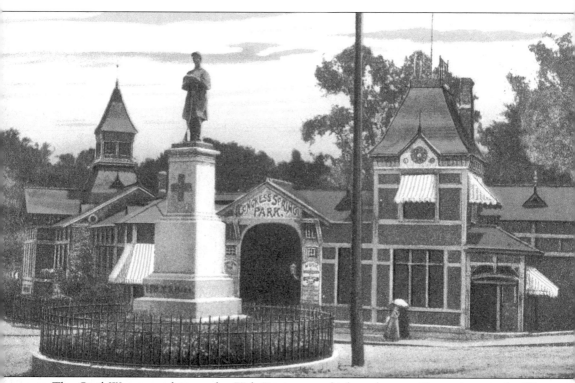

The Civil War statue honors the 77th Regiment, which took many Saratogians to the War Between the States. Through the 19th century, architectural celebrations changed with the times, as seen in the new entrance to the park.

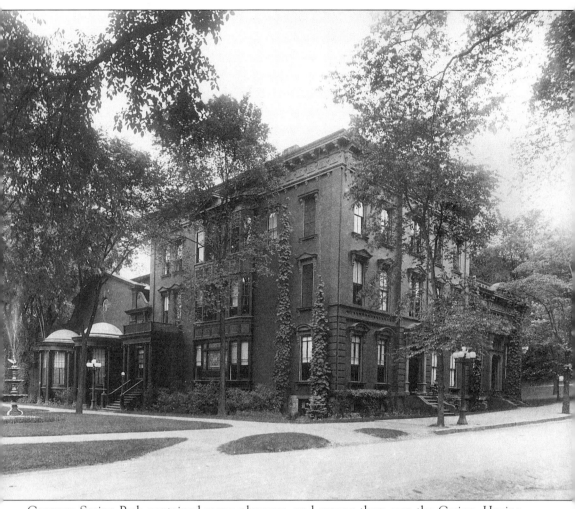

Congress Spring Park contained many pleasures, and among them was the Casino. Having opened as the Clubhouse in 1870, the Casino was in its day the scene of the biggest gambling games in the world.

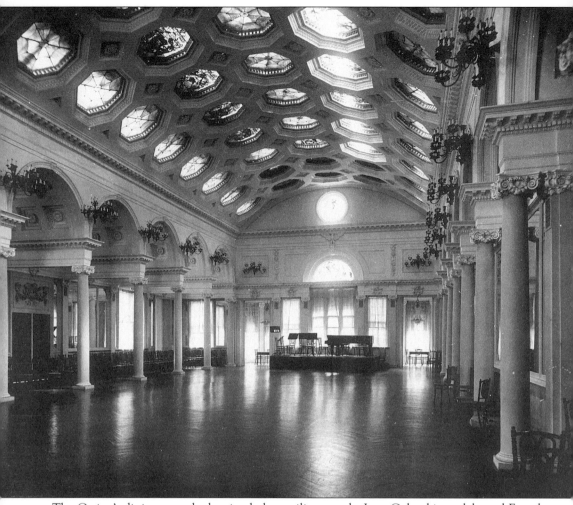

The Casino's dining room had stained-glass ceiling panels. Jean Columbin, celebrated French chef, ruled the kitchen. Patrons could pick their dinner from a pool of succulent fish out front. It was later reported that an underground chute returned the choices back to the pool, as the chef preferred to make his own selections.

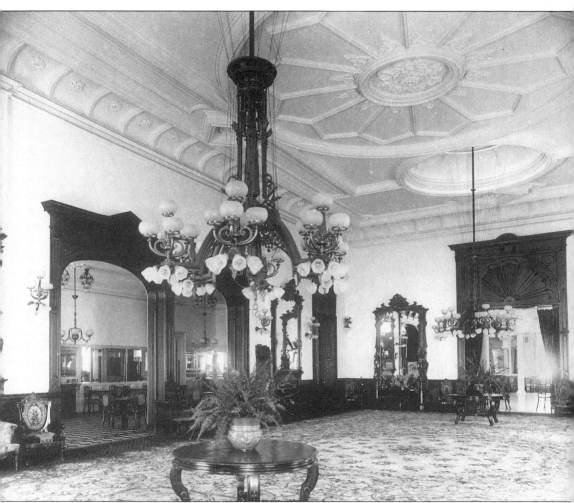

Upstairs, in the Casino's game room, the leading figures of the day—such as Cornelius Vanderbilt, J. Pierpont Morgan, the Whitneys, politicians, actors, and racing luminaries—came to play for high stakes. One summer day in 1902, John W. "Bet-a-Million" Gates, having lost $400,000 at the track in the afternoon, compounded his losses at the gaming tables to well over $500.000. Calmly, he asked that the regular limit per play be raised. At $10,000 a play, he had cut his losses to $250,000 by dawn the next day. He went home satisfied. "For me, there's no fun in just betting a few thousand," he explained.

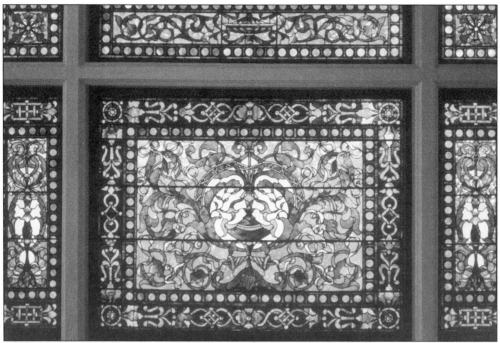

Shown are the bay window, above, and the cut-glass doors that lead to the barroom. Among the makers of the stained glass in the Casino was Tiffany. In the 1890s, other gambling houses were established in Saratoga, none rivaling the Casino's splendor.

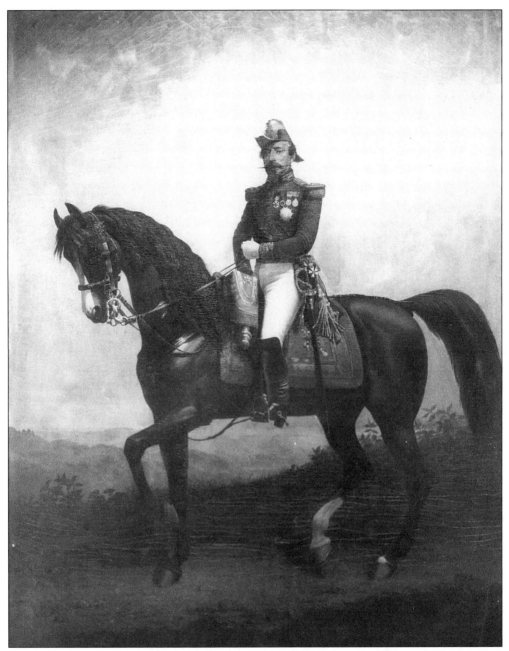

Joseph Bonaparte, the ex-king of Spain, came to Saratoga in 1836 with his nephew Napoleon III. This painting of Napoleon, formerly at the Tuilleries, made a nice wall hanging in the ballroom when the proprietor added it to the décor. Bonaparte bought an island on the St. Lawrence River and enjoyed holding court there for years.

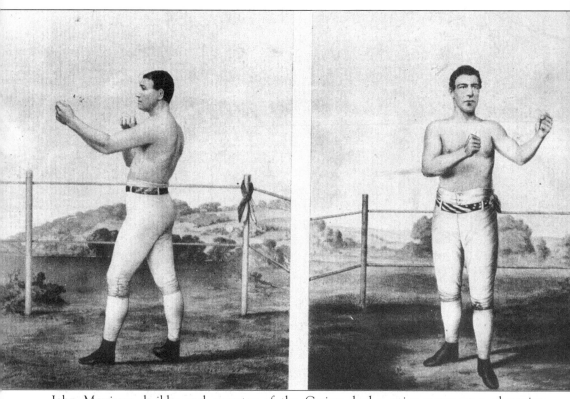

John Morrissey, builder and operator of the Casino, had a prior career as a champion prizefighter. He practiced both boxing and casino operation in New York City before coming to Saratoga. He served as a U.S. congressman and a state senator.

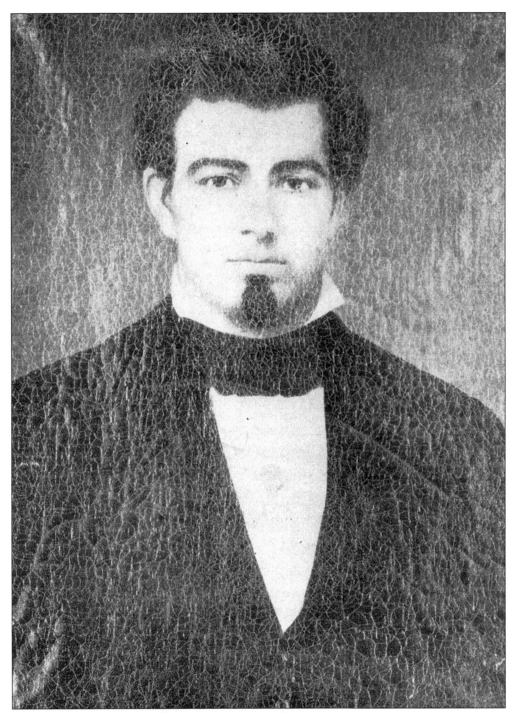

John Morrissey pursued his highly successful gambling operation as a route to acceptance in Saratoga society. To avoid offending the community, he did not allow Saratoga residents to gamble and he forbade gaming on Sunday. However, he never gained intimacy with "the cream" of Saratoga. He had mixed fortunes in investments, losing much in railroads. His health failed early, and he died at age 47 in 1878.

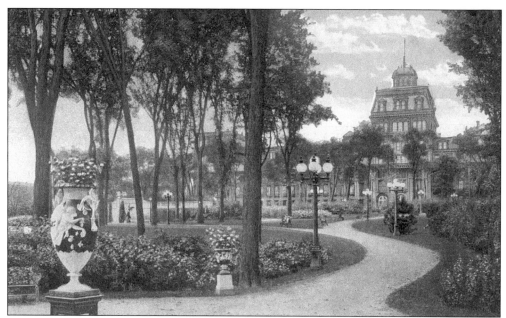

A stroll in the park was enhanced by statuary and carefully sculpted views. The vase at left was modeled by Danish sculptor Albert Bartholomew Thorvaldsen in the early 1800s.

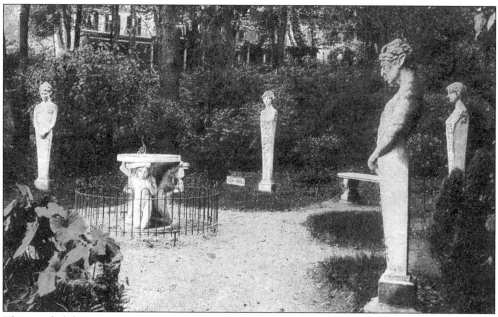

This sundial, honoring its original in Lugano, Italy, was set amid brooding mythological figures of Carrera marble.

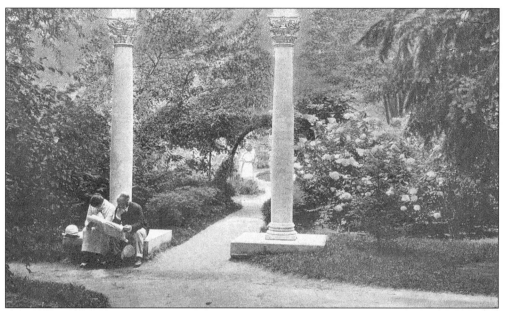

These Corinthian columns frame an entrance to the garden, above. A favored feature inside is the double fountain of Spit and Spat, below, perpetually blowing streams of water at each other, creating showers of diamonds in the sun.

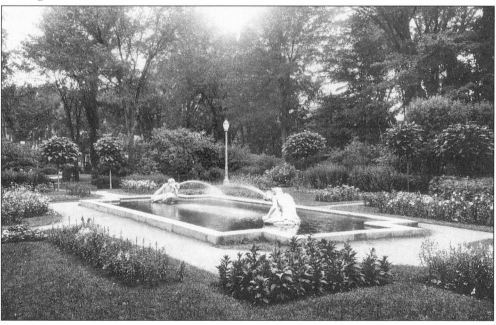

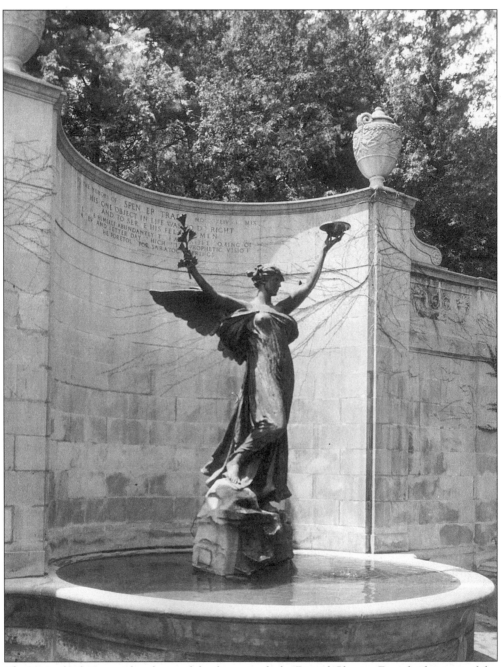

The Spirit of Life is considered one of the finest works by Daniel Chester French, designer of the Lincoln Memorial and other admired monuments. *The Spirit* was dedicated to Spencer Trask, financier and patron of the arts.

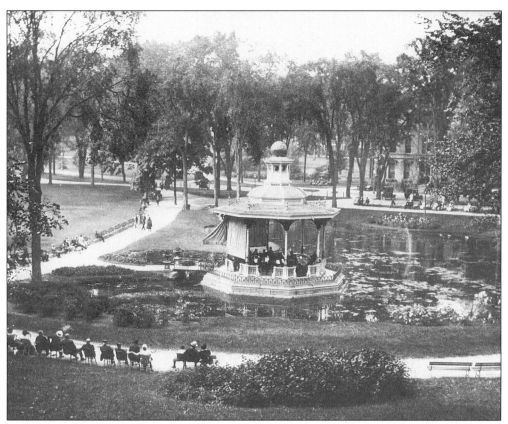

The first bandstand in Congress Park was placed in the spring-fed pond in 1882. The park always provided an enjoyable afternoon on a sunny day. Regular band concerts entertained strollers and sitters, below.

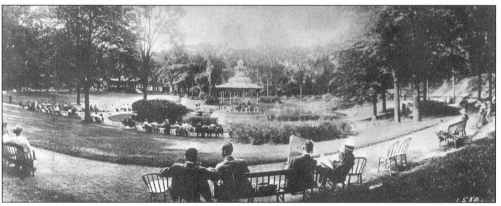

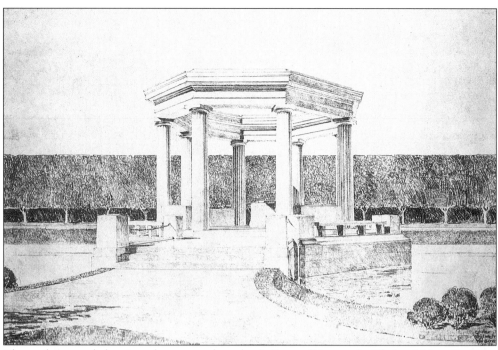

The architectural drawing above was done by LaFarge, Warren & Clark of New York for the memorial to those who served in World War I. Dedication ceremonies took place on June 14, 1931, below.

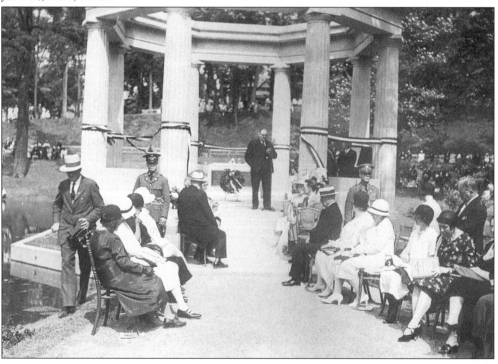

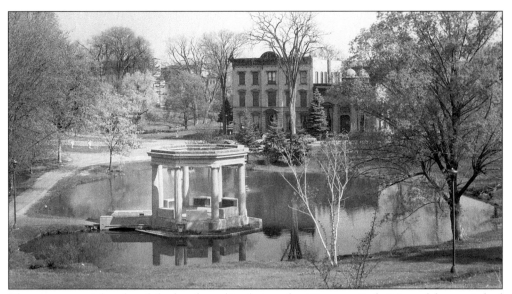

The war memorial replaced the bandstand in the pond at Congress Park. Most of the music had moved indoors and, along with the gambling, started a new look to entertainment in the nightclubs around Saratoga Lake.

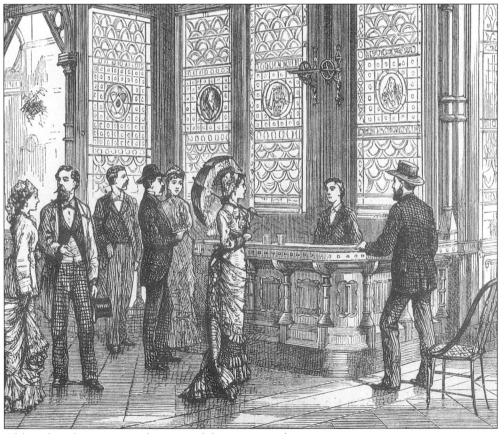

Although styles move on, the spirit of the springs endures.

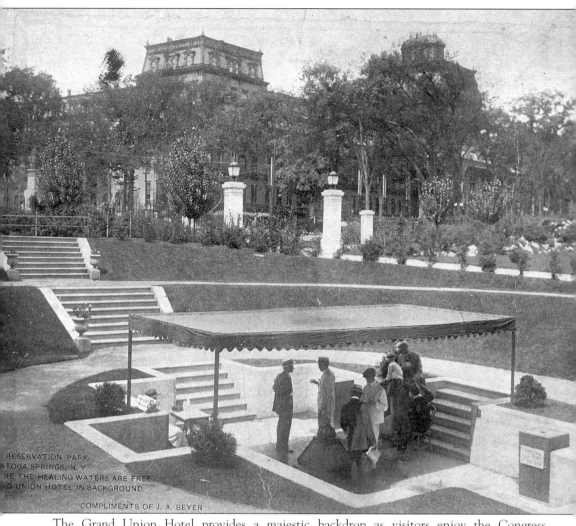

RESERVATION PARK
...TOGA SPRINGS, N. Y.
...RE THE HEALING WATERS ARE FREE
...D UNION HOTEL IN BACKGROUND

COMPLIMENTS OF J. A. BEYER

The Grand Union Hotel provides a majestic backdrop as visitors enjoy the Congress Spring waters.

Two

HOSPITALITY GRAND AND PLAIN

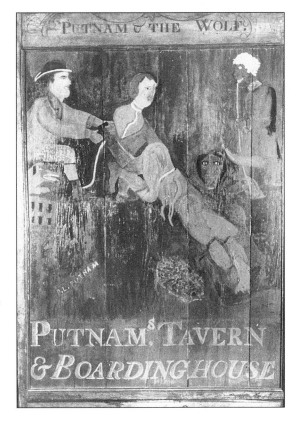

A young man named Gideon Putnam arrived in the Saratoga region in 1789 and made a successful business milling the abundant lumber. Having cleared a considerable part of the area around the springs, he ventured to build the first creditable lodgings. In 1803, his tavern and boardinghouse went up near the Congress Spring. Succeeding again, he bought up land and laid out a village with a broad thoroughfare passing in front of his boardinghouse.

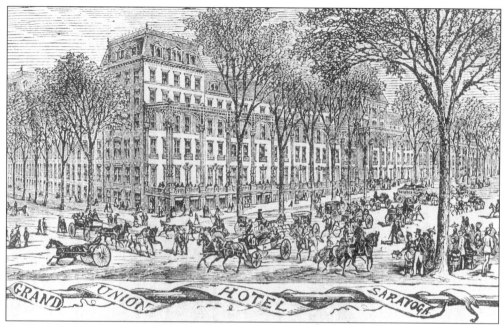

Gideon Putnam's rudimentary lodgings were expanded by his widow and children to Union Hall. In 1874, subsequent owners transformed the place into the monumental Grand Union Hotel.

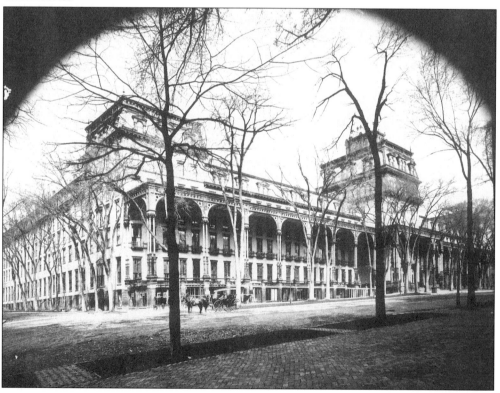

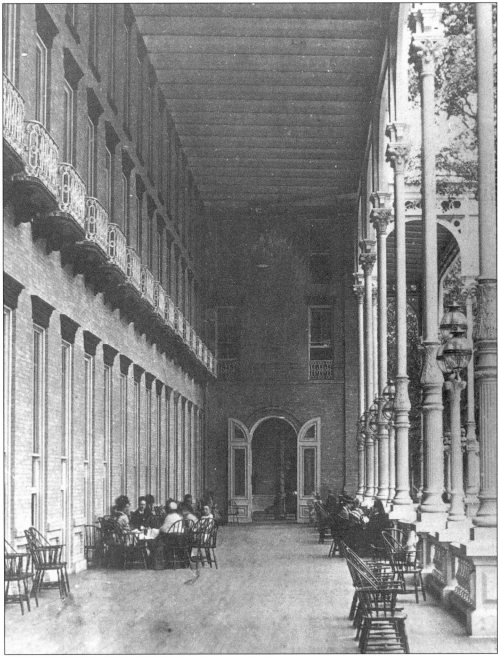

No one could feel grander than when sitting on the verandah. Victor Herbert conducted two concerts daily here, leading a 51-piece orchestra to the delight of the guests.

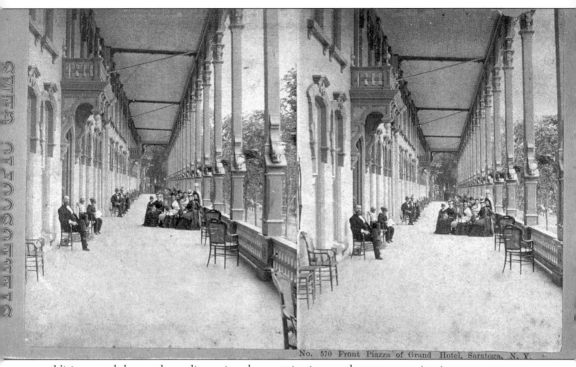

No. 570 Front Piazza of Grand Hotel, Saratoga, N. Y.

Visitors took home three-dimensional memories in popular stereoscopic views.

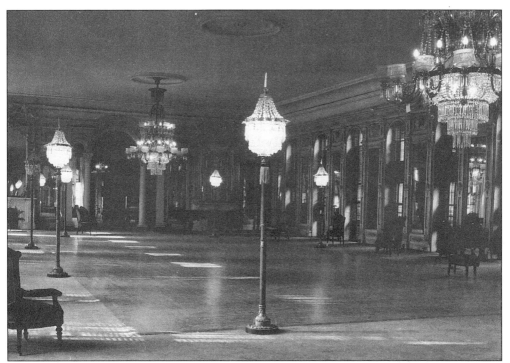

The handsome parlors and ballroom helped the Grand Union cover 7 acres magnificently. Thomas Edison's new incandescent lamp was first demonstrated at a courtyard ball, and its use was later extended throughout the hotel.

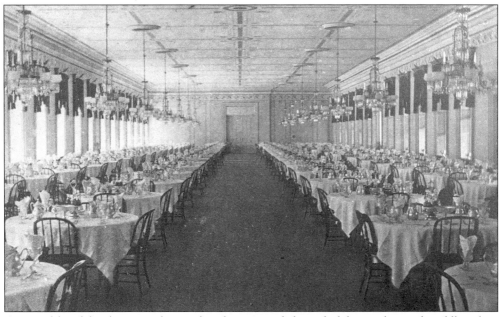

A typical breakfast began with cereal and progressed through fish, omelet, and griddle cakes, and a choice of cutlet or chop and cold ham or beef. There were fried potatoes as well as chocolate, coffee, or tea. After the Civil War years, the dining room was expanded to serve up to 1,400 at a time.

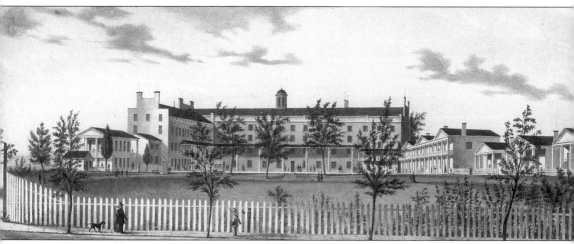

Rivaling and prospering alongside the Grand Union on Broadway was the United States Hotel. Reopened in the 1870s, after a fire made total rebuilding necessary, it too was on a massive scale. It had more than 700 rooms and enclosed a pretty 3-acre park. It also offered cottage suites that featured private baths.

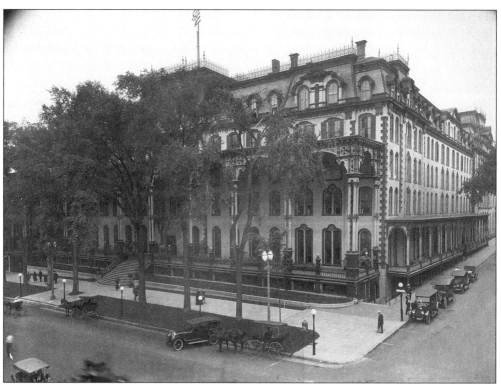

In addition to superbly appointed public rooms, the hotel had a 30-foot-wide verandah that offered guests a front-row seat from which to enjoy the passing parade on Broadway.

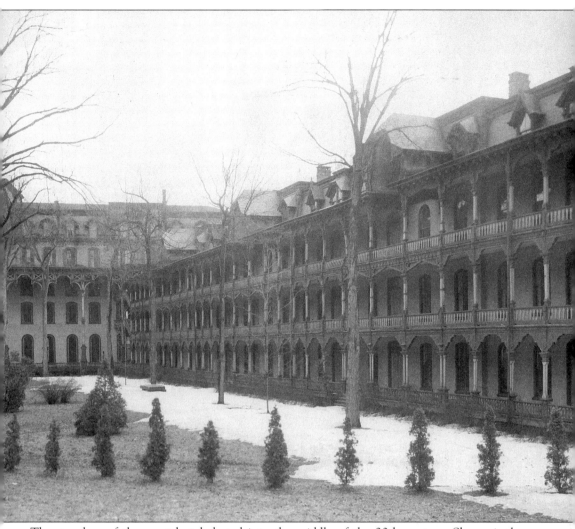

The grandeur of the great hotels lasted into the middle of the 20th century. Shown is the interior courtyard of the United States Hotel in 1946.

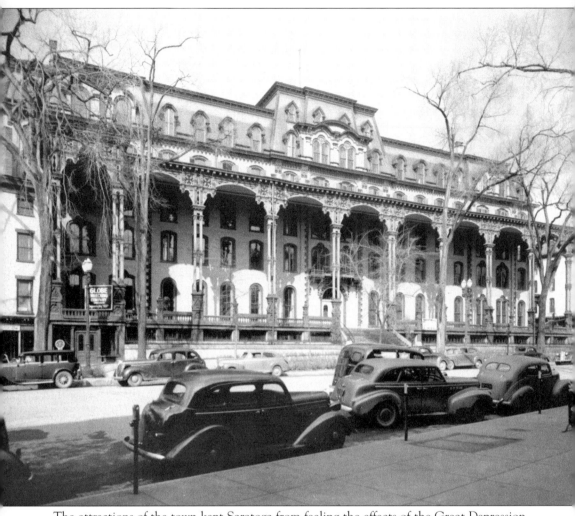

The attractions of the town kept Saratoga from feeling the effects of the Great Depression.

The hustle and bustle is muted on Division Street on a cool rainy afternoon.

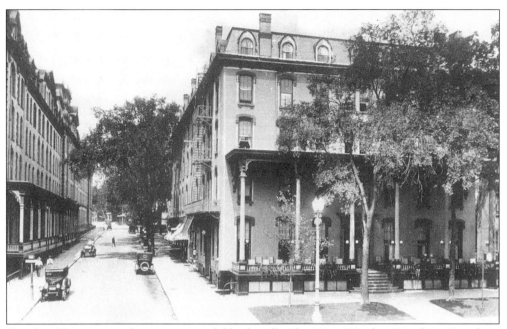

Comfortable accommodations are available for all. The New Worden Hotel, at Broadway and Division Street, was a favorite among local celebrities. The lounge was a reliable place to find Frank Sullivan—a celebrated humorist, a regular *New Yorker* contributor, and the "Sage of Saratoga."

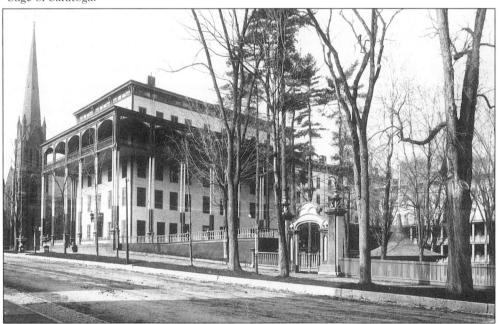

The Clarendon Hotel on South Broadway attained great success between 1865 and 1874 while the United States Hotel was being rebuilt. Distinguished visitors included William R. Travers, the first president of the Saratoga Racing Association; Leonard Jerome; and Jerome's daughter Jenny Jerome, who married into English society and bore the future statesman Winston Churchill.

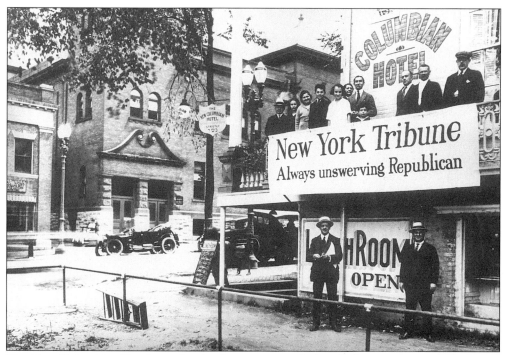

The New Columbian Hotel was the third incarnation of a hotel of this name.

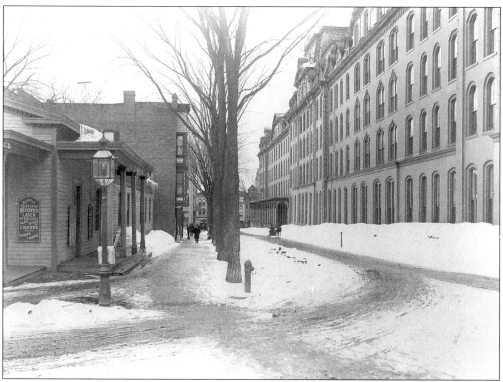

This view from Railroad Place looks toward Broadway along Division Street. The United States Hotel on the right is shadowed by more modest public houses.

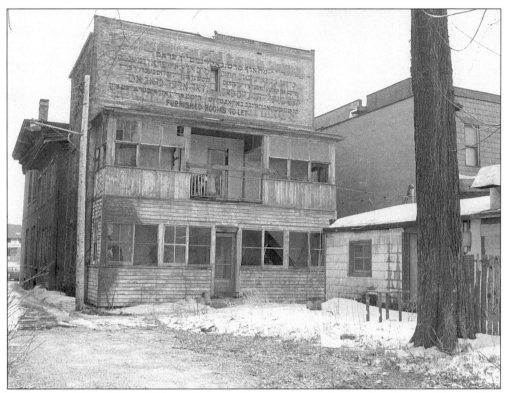

Looking east from Railroad Place, this view shows a rooming house that has seen better days. It serves as a reminder that leading exponents of the spas had been Hasidim since the early days, coming to Saratoga during the summer, as in the European tradition.

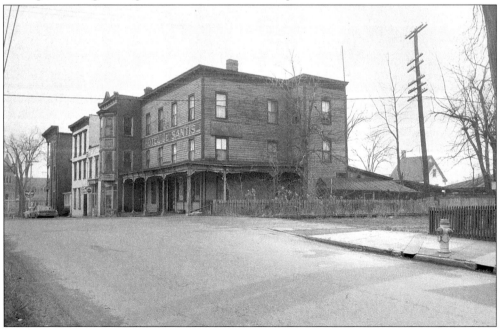

Saratoga was for everyone. Shown is the Hotel DeSantis in its latter days.

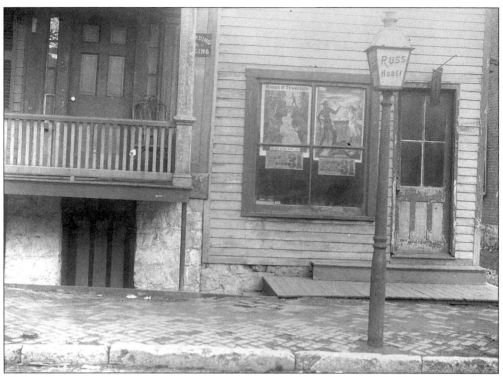

Although supremely unpretentious in some ways, the Russ House did offer moving picture entertainment. It is shown as it appeared in March 1902.

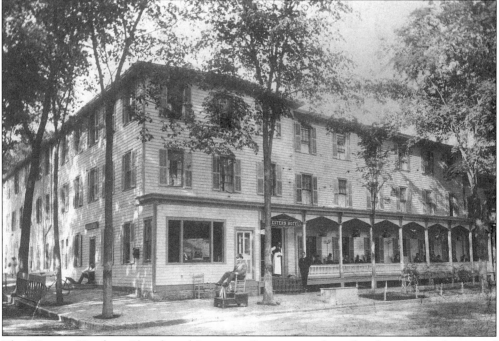

The Western Hotel, at Church and Lawrence Streets near the railroad station, is the type of place in which a traveling salesman might have stayed.

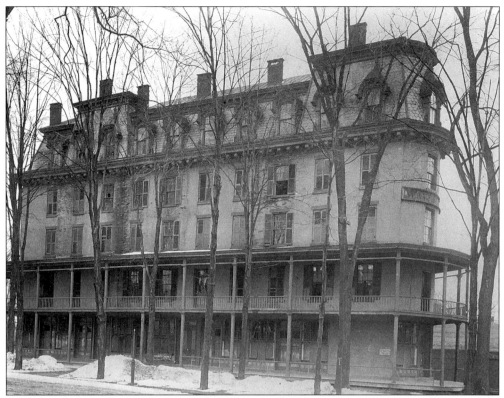

The Waverly Hotel had many visitors from far away, being popular especially among those from the South. A station on the narrow-gauge Saratoga, Mount McGregor, & Lake George Railroad was built alongside the flatiron-shaped building in 1882, providing convenient travel to wonderful views up-country.

Traffic is always a challenge on Broadway.

Three
Tranche de Vie:
A Slice of Life

Events such as the Blizzard of 1888 did not stop the flow of life on Broadway, as is shown here in front of the American and Adelphi Hotels.

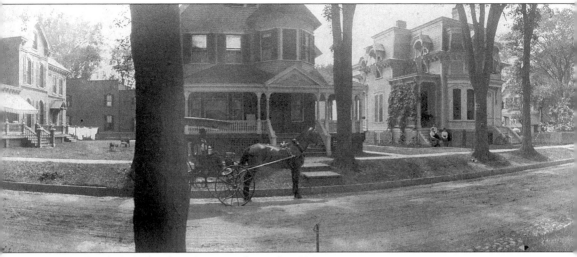

It is a fair day on Caroline Street in the early 1900s.

During a Saratoga winter, all is quiet on Circular and Phila Streets in February 1910.

"Because You Love Nice Things." So attested the Van Raalte Company, which took over from Clark Textiles in 1919. City improvements under way in front of the world-famous lingerie company's Saratoga Springs plant fascinate a group of children.

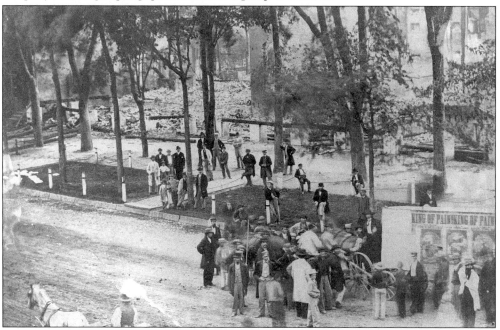

Reconstruction in Saratoga Springs (1865) saw a great conflagration take down the United States Hotel, causing much excitement. Remedies were at hand. Saratoga's prosperity had been paramount throughout the Civil War, as the industrialists feeding the Union armies made it their vacation place. Renovation and improvement were immediately put in motion.

RACE

OF

ONE-LEGGED SOLDIERS

ON THE

Fair Ground Track,

SARATOGA SPRINGS,

Saturday, Aug. 7, 1869,

AT 4 P. M.

E. B. BRANCH, of Rock City Falls, late of Co. D, 77th N. Y. Vols.,

HEREBY CHALLENGES

the One-Legged Soldiers of the State of New York to a

HALF-MILE RACE

at the time and place above named, for the GATE MONEY taken at the race.

AT LEAST SIX MEN,

who reside in and near Saratoga, will run, and 15 or 20 more are expected.

THERE WILL BE LOTS OF FUN!

Come one, come all, and let the best Man win.

Admission to the Grounds, - 25 Cents

Saratoga had given deeply to the war in other ways. Meetings of the Grand Army of the Republic started soon and continued beyond the end of the century. The New York 77th Regiment was largely comprised of Saratoga County men.

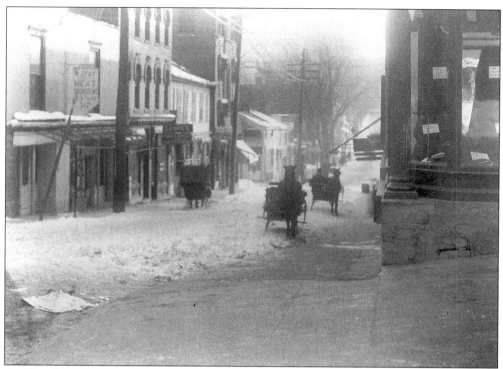

Caroline Street has long been at the center of the city. In 1903, traffic moves along and business continues unimpeded by the snow.

This 1938 image shows Caroline Street, vibrant with family-owned enterprises.

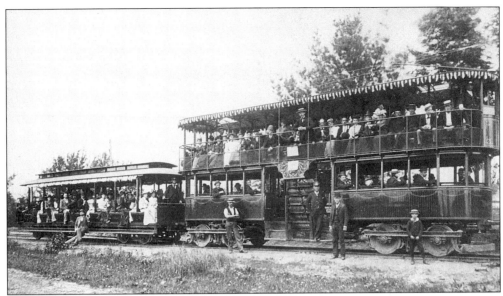

Shown in this *c*. 1905 image is the Union Electric Railway's open car No. 24, which ran from Saratoga Springs to Saratoga Lake.

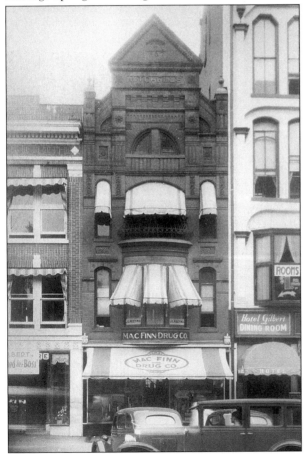

Homegrown businesses prosper in Saratoga. When possible, they put on an elegant front.

In the 1920s, the old jail at 62 Congress Street was converted into a nightclub called the Green Cave.

This view looks west on Washington Street from Broadway.

Shown is the traditional structure at the site of the original Bryan House on Maple Avenue. Alexander Bryan was a pioneer hero. The first permanent settler to keep a public house for visitors, he played a role in the Battle of Saratoga. He provided early information on the British army's advance, allowing timely preparations for the engagements on September 19 and October 7, 1777. This information was important to the final victory of the Revolutionaries on October 17, 1777. Bryan built his tavern above High Rock Spring in 1787.

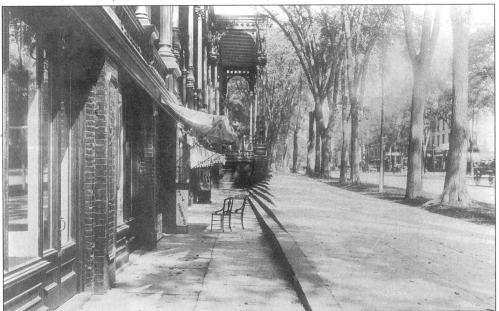

This view of South Broadway, looking north, shows the Grand Union Hotel and the shops beneath it, on the street level.

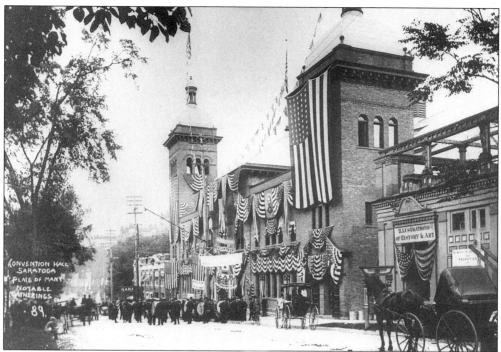

Convention Hall hosted everything from grand opera starring Enrico Caruso to donkey basketball. In this 1906 image, a parade of the Grand Army of the Republic passes in front of the hall. The House of Panza (the Pompeia) stands on the right. It held the largest and most complete replica of a Pompeian villa ever constructed. The effect was enriched (though possibly confused) by the addition of curiosities, such as the bronze lamp of a human foot, the slave collar, the Egyptian mummy, and a badly stuffed peacock.

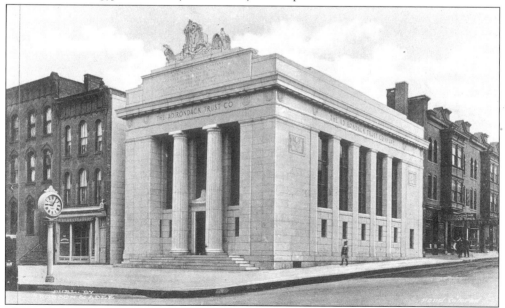

The Adirondack Trust Company was a cornerstone of the community at Broadway and Lake Avenue.

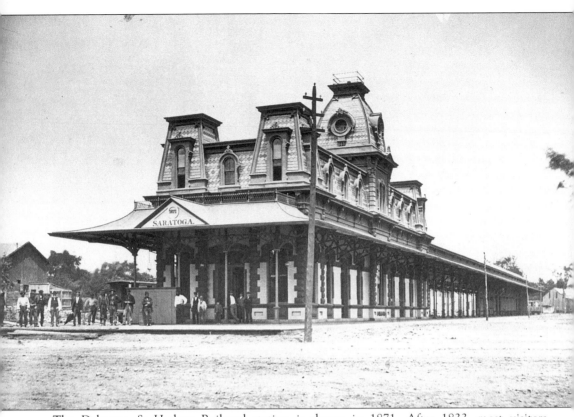

The Delaware & Hudson Railroad station is shown in 1871. After 1833, most visitors came to Saratoga by train. Arriving in luxurious Pullman cars, coach class, or horsecars, all were welcome.

Four

CHARACTER OF ALL KINDS

Excellent photographic services were available to capture the city's life and summer memories.

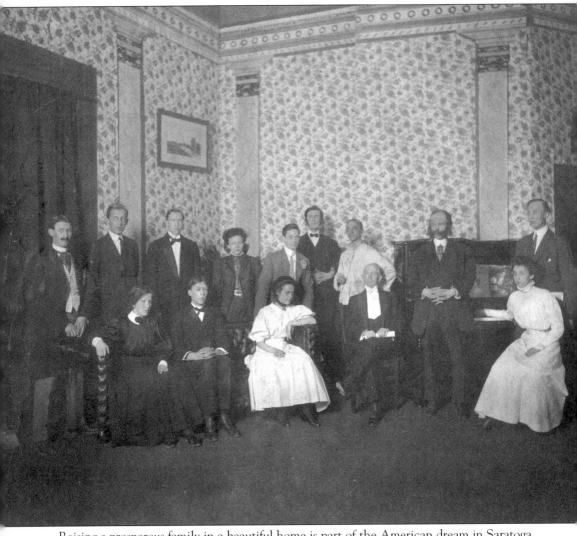

Raising a prosperous family in a beautiful home is part of the American dream in Saratoga.

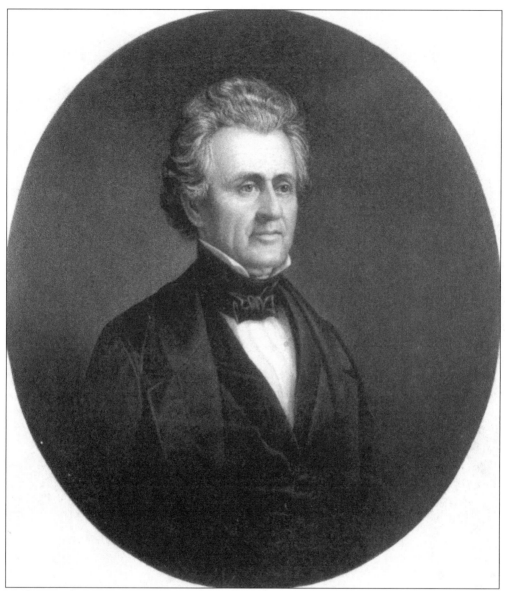

Reuben Hyde Walworth, the last chancellor of the State of New York (1824–1848), was deemed great by historians for simplifying and streamlining the equity laws of the United States. The leading lights of the age came to his estate, Pine Grove, to share in the philosophy and development of American law. These luminaries included Daniel Webster, Henry Clay, and many others. Ellen Hardin Walworth was a powerful advocate for heritage preservation. Her legacy includes working to establish the Library of Congress, the Washington and Saratoga Monuments, and the Daughters of the American Revolution.

Sen. Edgar Brackett was an excellent and foresighted representative who originated legislation saving the springs, which were being stripped of their carbonation for use in soft drinks. Thus was created the New York State Reservation, a source of mineral waters and home of refreshment and entertainment for the public good. The senator was also a founding member of the McGregor Golf Club.

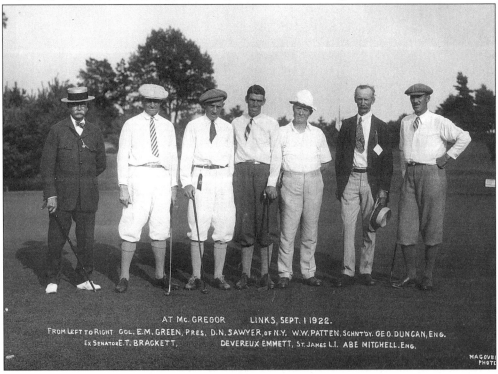

AT Mc. GREGOR LINKS, SEPT. 1 1922.
FROM LEFT TO RIGHT COL. E.M. GREEN, PRES. D.N. SAWYER, OF N.Y. W.W. PATTEN, SCHNT'DY. GEO. DUNCAN, ENG.
EX SENATOR E.T. BRACKETT, DEVEREUX EMMETT, ST. JAMES L.I. ABE MITCHELL, ENG.

MAGOVE
PHOTC

Lt. Charles Brackett, son of Sen. Edgar Brackett, poses having returned home from service in World War I. He went on to gain renown for his work as a producer in Hollywood, working with Billy Wilder on films such as *Ninotchka*, *Five Graves to Cairo*, *Lost Weekend*, and *Sunset Boulevard*.

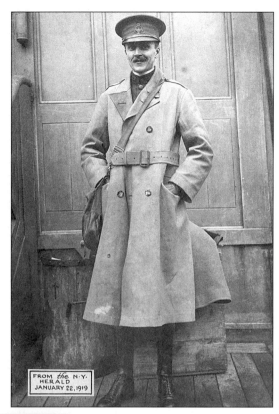

FROM *the* N·Y·
HERALD
JANUARY 22, 1919

John Slade was called "Mr. Saratoga." In community service for most of his 87 years, he was a dependable figure to be seen strolling Broadway daily, contemplating developments surrounding Skidmore College, Yaddo, and child and women's protection issues.

James A. Leary and Walter Fullerton are shown at the beginning of their law practice in 1910. Professional firms were allowed to rent space in city hall. Leary made good use of the location, being fully embroiled in city affairs and politics for 50 years.

Robert Gass was another stalwart spanning most of the century. He served for 50 years, starting in 1934 as city assessor. He took a sincere interest in the city and developed a detailed knowledge of it. He went daily to city hall, even after retirement, until his death in 1991.

R. Newton Brezee brought the High Victorian and later styles to fine residences and buildings in Saratoga. He came to the area in 1867 at age 16 as a carpenter. He became a self-trained architect, producing more than 50 distinctive buildings in town.

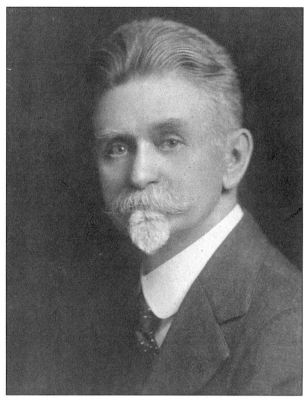

The building at 511 Broadway was constructed for Dr. John D. Morierta, a physician, surgeon, and pioneer in radium and insulin.

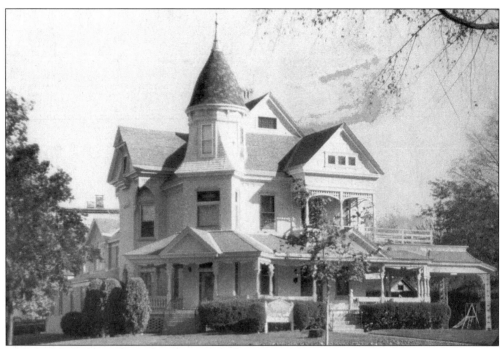

Built in 1885–1886, this Lake Avenue residence was among R. Newton Brezee's most ornate and complicated designs.

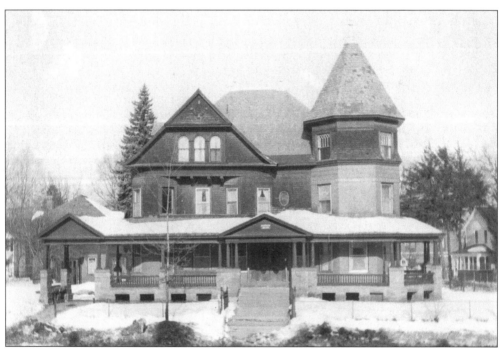

This house stands on the "Avenue of Champions," Union Avenue, between Congress Park and the Saratoga track. It was built in 1901 for the Crippen family.

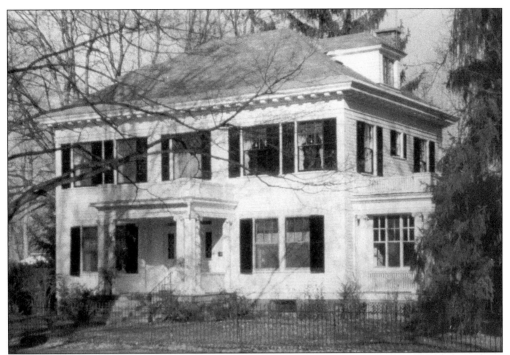

On the east side of town, this house on Fifth Avenue exemplifies Greek Revival serenity and simplicity.

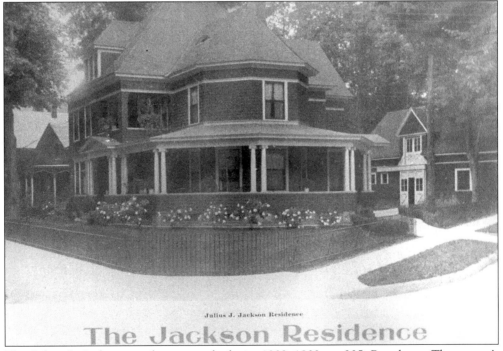

Julius J. Jackson Residence

The Jackson Residence

The Julius J. Jackson residence was built in 1902–1903 at 205 Broadway. The owner's company, Liberty Wallpaper, prospered in nearby Schuylerville. It boasted the world's largest wallpaper press.

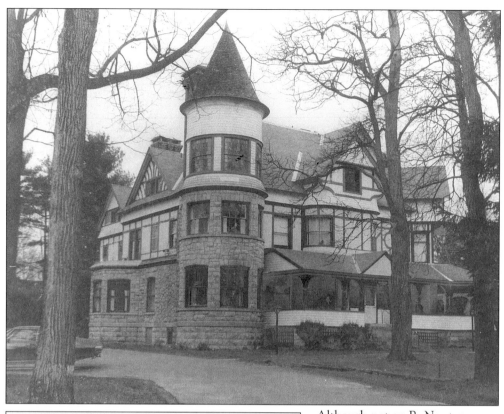

Although not an R. Newton Brezee design, the Annandale is distinctive. It stands amidst other mansions in the Clinton Street area.

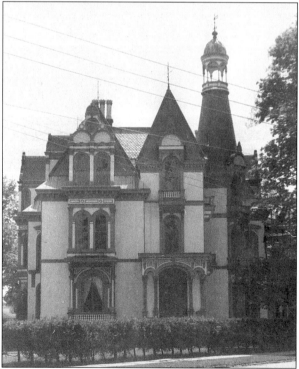

The Batcheller Mansion on Circular Street overlooks Congress Park. It was designed, built, and copyrighted in 1873 for its occasional residents, Judge Batcheller and family.

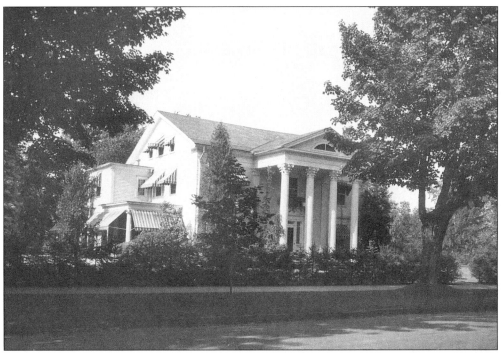

This fine Colonial stands on the corner of Fifth and East Avenues.

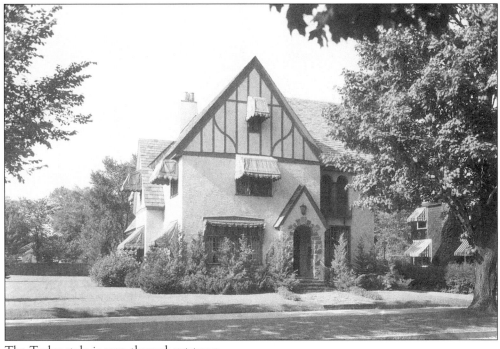

The Tudor style is seen throughout town.

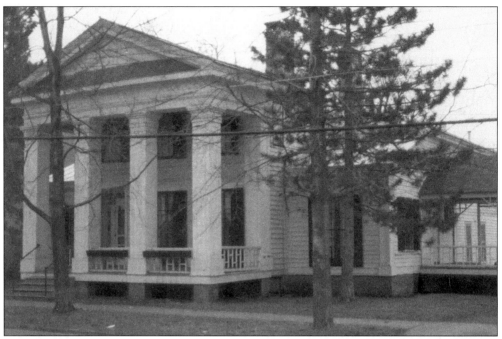

This Circular Street home was originally the Jumel Mansion. Eliza Jumel was one of the most controversial and colorful summer residents who came to the Spa in the 1830s and 1840s. For a time, she led the daily procession of carriages from Broadway to Saratoga Lake. She enjoyed the fullness of life with a succession of marriages. Gossip about her modest beginnings tempered some of her pleasure, as did a brief marriage encounter with Aaron Burr towards the end of his life.

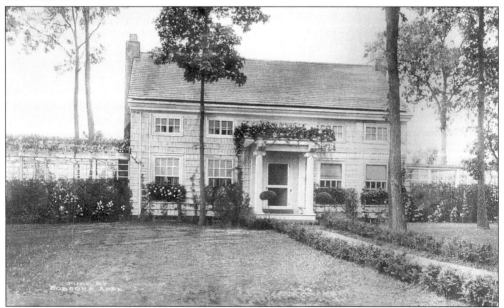

Near the Annandale is Inniscarra, which was built in 1903 for Chauncey Olcott, a singer and songwriter. The great Irish tenor, originally from Buffalo, was famous for singing "When Irish Eyes Are Smiling" and for writing "Wild Irish Rose" and "Mother Machree."

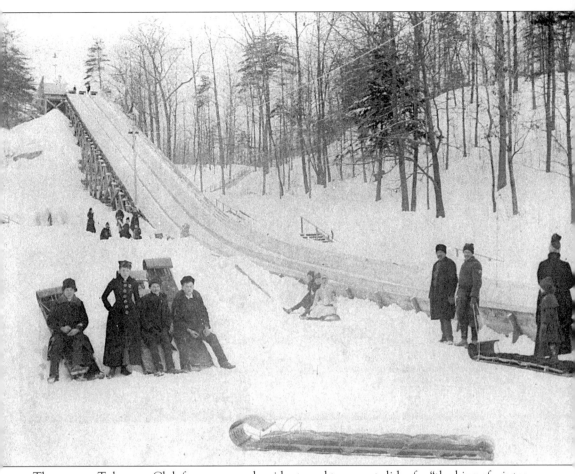

There was a Toboggan Club for year-round residents and two great slides for "the king of winter sports." This one was at Glen Mitchell, shown in 1890.

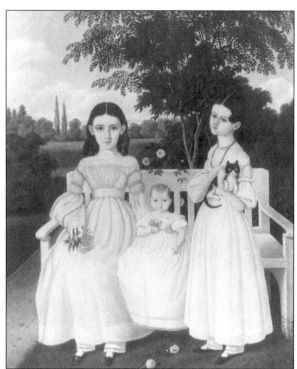

Shown is *Three Sisters in a Landscape*, by Henry Walton, *c.* 1838. Walton was born into a prominent family, the son of Judge Henry Walton, who owned much of Saratoga Springs. He was sent to England to be educated, and he later studied law in New York City with Aaron Burr. Although a contemporary of artists of the Hudson River School, he worked independently. He is known for portraits of children, views of western New York State, and scenes of gold rush activity in California in 1851. The family lived first at Pine Grove and then at Woodlawn, a large estate out North Broadway, now the site of Skidmore College.

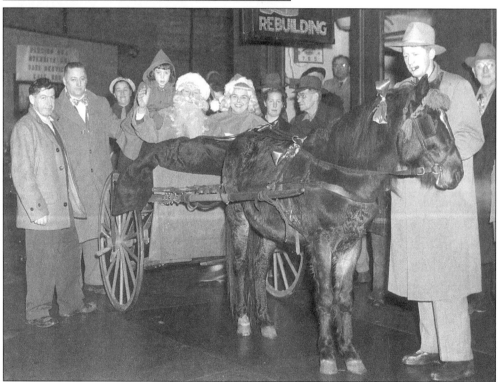

This Santa Claus village scene shows Santa Claus, Mrs. Claus, Al Braim, and others in December 1949.

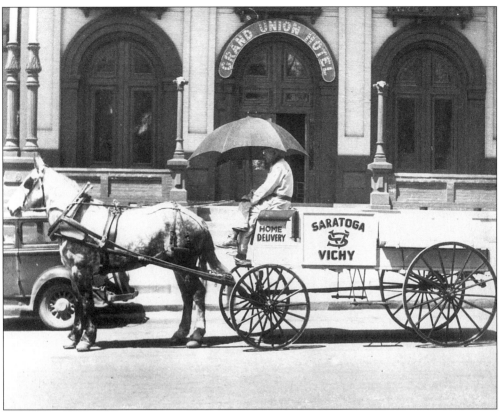

Shown is a traditional delivery system for a popular water in 1949.

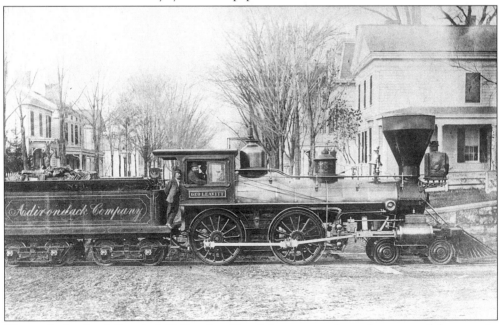

The tracks for the Adirondack Railroad at Grand Avenue ran down the center of the street in the middle of town.

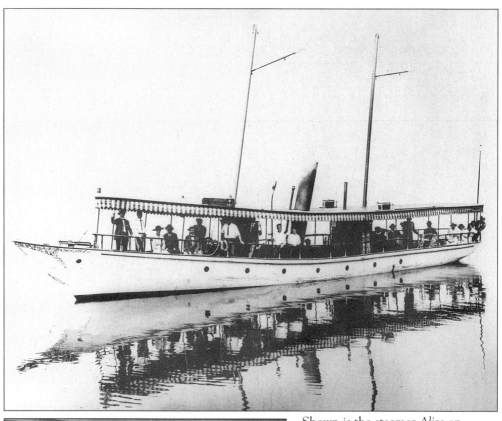

Shown is the steamer *Alice* on Saratoga Lake, *c.* 1900. It was owned by Tom Luther of the White Sulphur Springs Hotel. Beginning in 1845, when the *R.B. Coleman* was launched, visitors on lake steamers were treated to cool air, scenic views, and tales of earlier times.

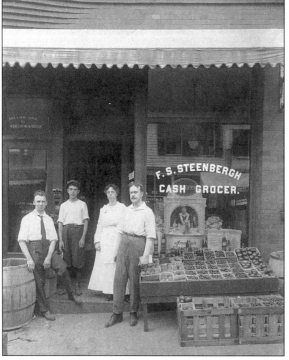

The F.S. Steenbergh family prospered in their Caroline Street grocery. This photograph dates from 1915.

This store on Church Street seems to be living off the fat of the land.

The gaslit interior shows off sundry goods at Starbuck's department store in 1887. This well-known emporium served several generations.

As elsewhere in America, social organizations flourished, combining "eastern" garb, ritual, and American flags.

An international effect was never neglected, as is shown by the Japanese Tea Garden in Congress Park.

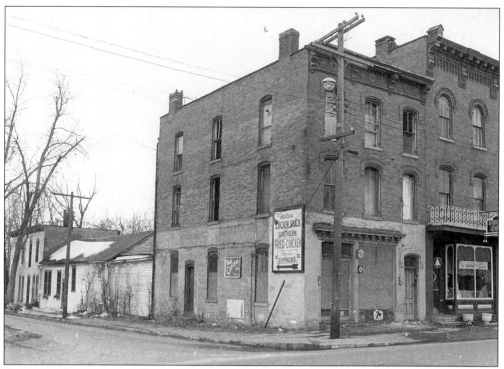

Shown is the corner of Congress and Federal Streets at the very beginning of Saratoga's renaissance, the end of the 1950s. One of the enduring institutions is Hattie's, serving the best southern fried chicken in the North.

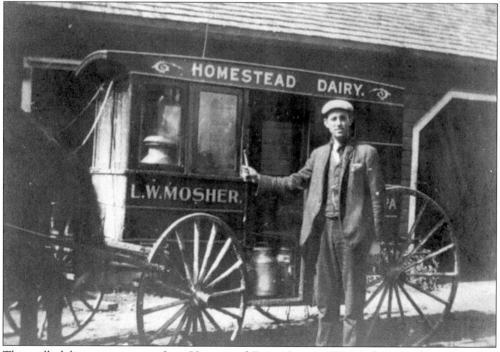

This milk delivery wagon was from Homestead Dairy. Lawson W. Mosher was the proprietor.

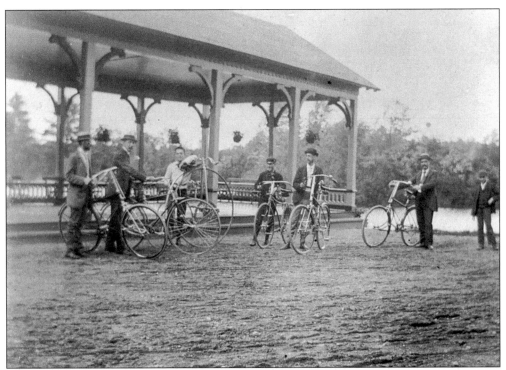

Shown is the latest wheeled invention on June 23, 1891, at Woodlawn Oval.

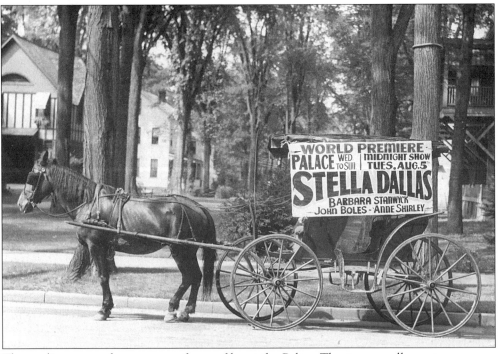

The medium meets the message: a feature film at the Palace Theatre goes all over town.

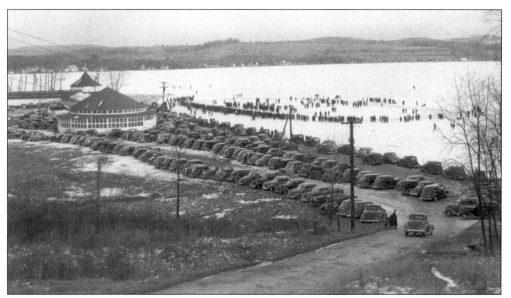

Kaydeross Park on Saratoga Lake was popular year-round. In winter, it was a favorite destination for skating and other social outings.

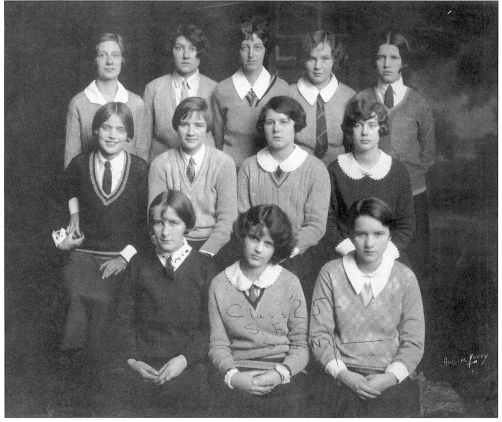

Shown is the Class of 1925 at St. Faith's Private School on Seward Street. The school was founded by Eleanor Shackelford, great-granddaughter of Gideon Putnam.

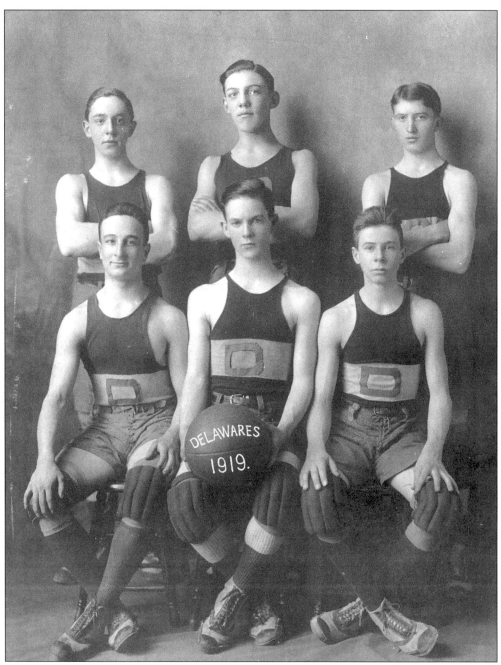

These are the 120-pound champions of 1919. Shown, from left to right, are the following: (front row) B. Gold, W. Cassidy, and P. Nichols; (back row) W. Joubert, W. Logan, and W. Folts.

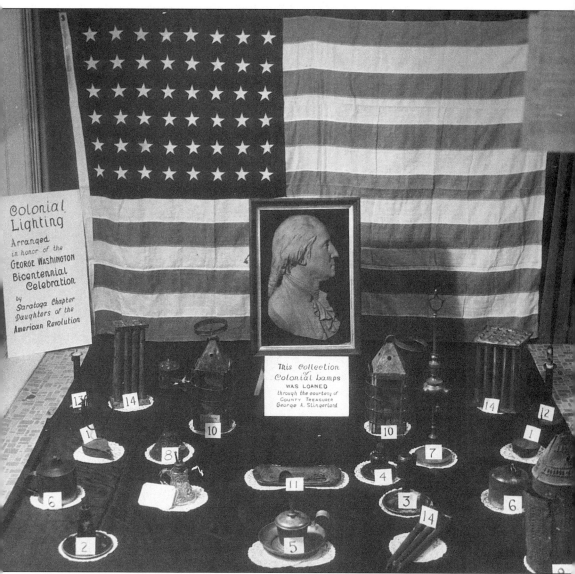

Shown on February 12, 1932, this collection of artifacts honored the bicentennial of the birth of George Washington. George Slingerland, the county treasurer, was a great collector of important artifacts. The celebration was arranged by the Saratoga chapter of the Daughters of the American Revolution. Lamp No. 1 was lit by Eleanor Roosevelt at the commemoration.

Silver plates and a silver tea service commemorate the George Washington bicentennial in February 1932. Shown below is a collection of dolls and miniatures.

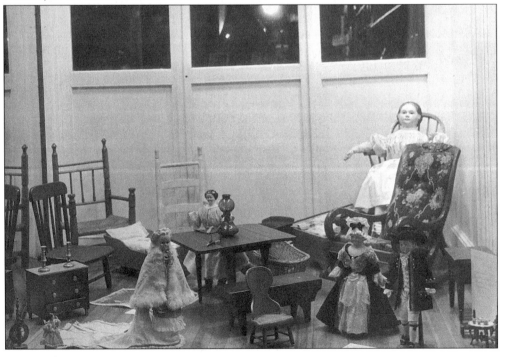

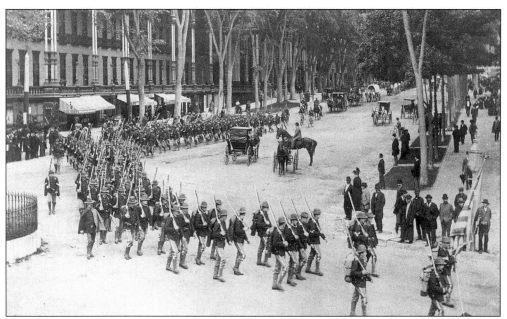

In this 1898 image, troops leave for the Spanish-American War. The Grand Union Hotel stands in the background.

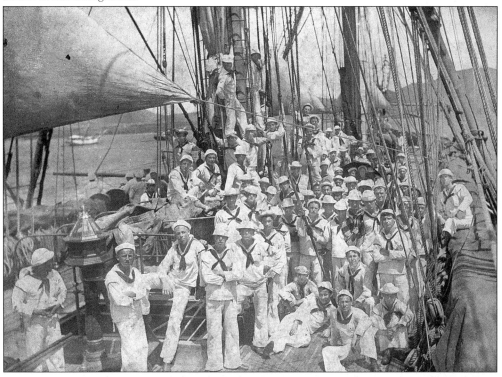

Aboard the Pennsylvania nautical training ship PNSS *Saratoga*, a liberty party prepares to go ashore at St. Kitts, West Indies, in 1897. Naval vessels have borne the name Saratoga regularly in memory of the crucial Revolutionary War battle. One of those who served on this ship was Jack Norworth—actor, musician, and writer of the song "Take Me Out to the Ball Game."

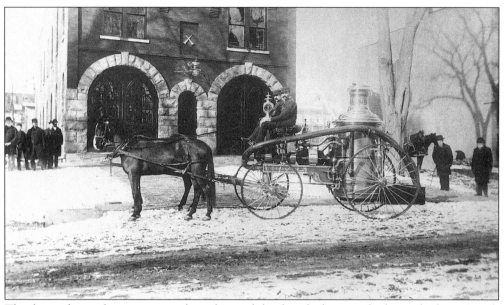

This horse-drawn fire wagon stands in front of the first firehouse, which was built on North Broadway in 1883.

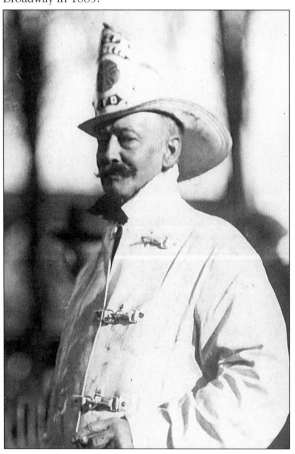

E.J. Shadwick (1853–1929) was Saratoga's first fire chief.

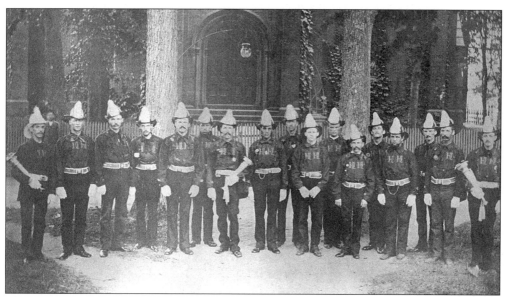
This *c.* 1871 image shows the Hathorn Hose Company No. 2, an early volunteer company.

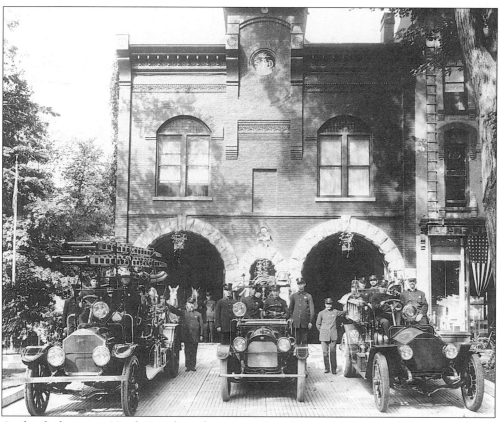
At this firehouse on North Broadway, horses stand ready in case of engine failure.

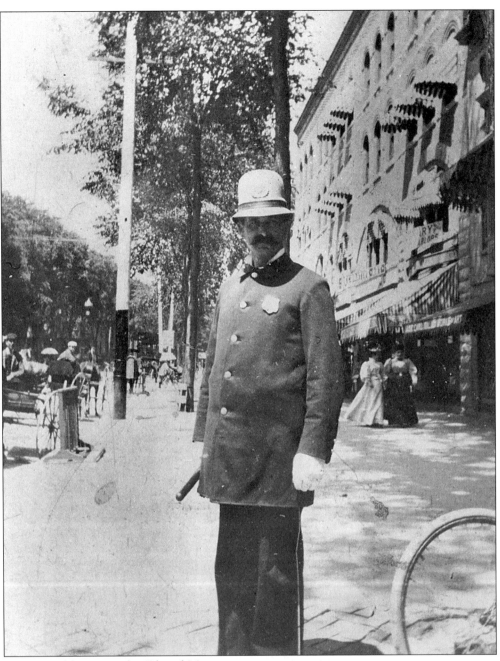

This constable on patrol is Edward Morrison.

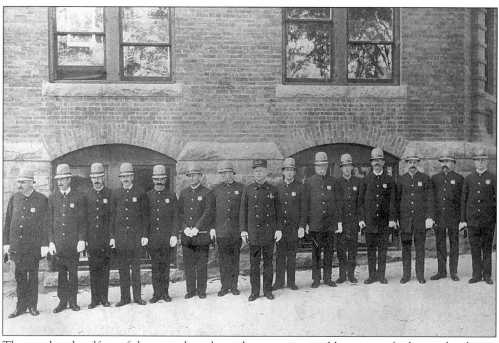

The good and welfare of the town has always been maintained by respect for law and order.

Shown in 1909 is a group of postal workers.

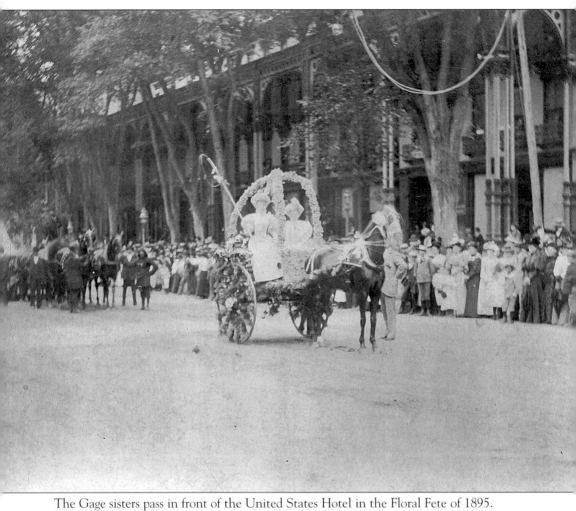

The Gage sisters pass in front of the United States Hotel in the Floral Fete of 1895.

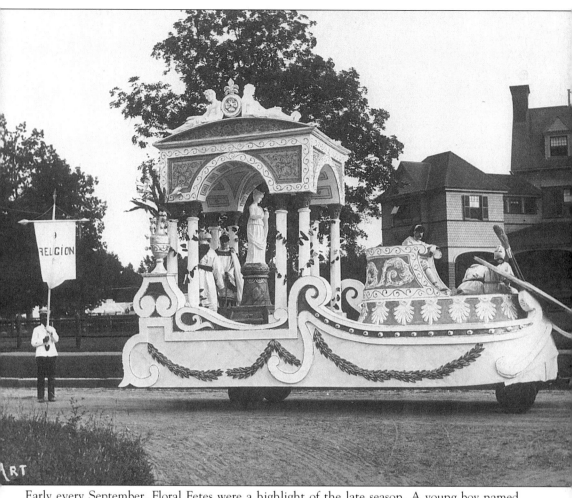

Early every September, Floral Fetes were a highlight of the late season. A young boy named Monty Woolley had his appetite for theater whetted by riding in the procession.

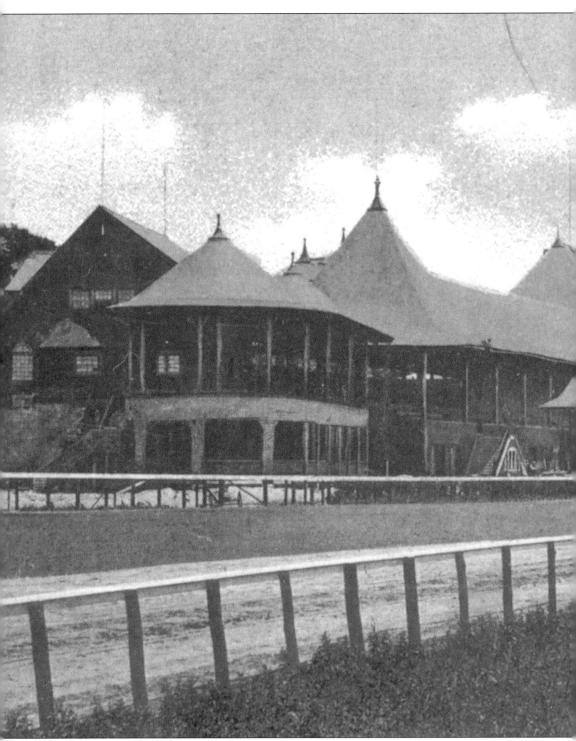

Saratoga Race Course is shown in this 1908 view. The idea of establishing a horse-racing track resulted from a combination of talents. Men of substance and imagination, such as William R. Travers, Leonard W. Jerome, and John Morrissey established the first track in 1863. This one

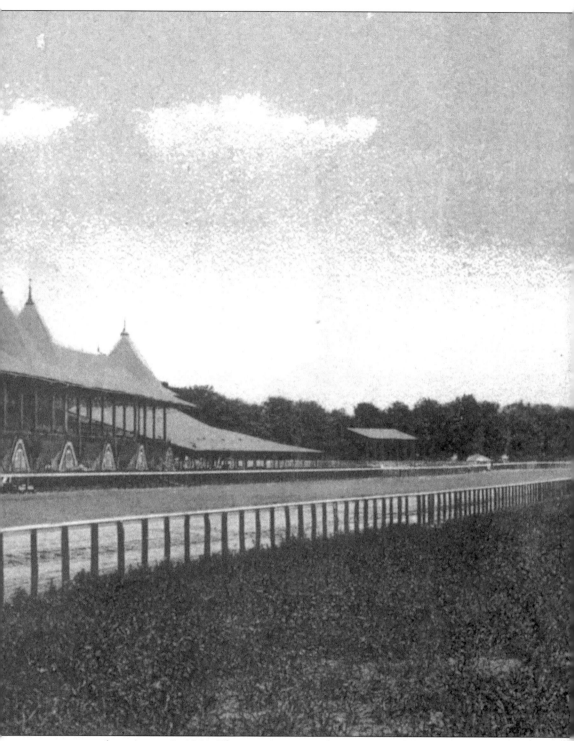

was inaugurated on August 2, 1864. The entrepreneurs who provisioned the Union armies for the Civil War came to summer at Saratoga as usual, far from the battlefields.

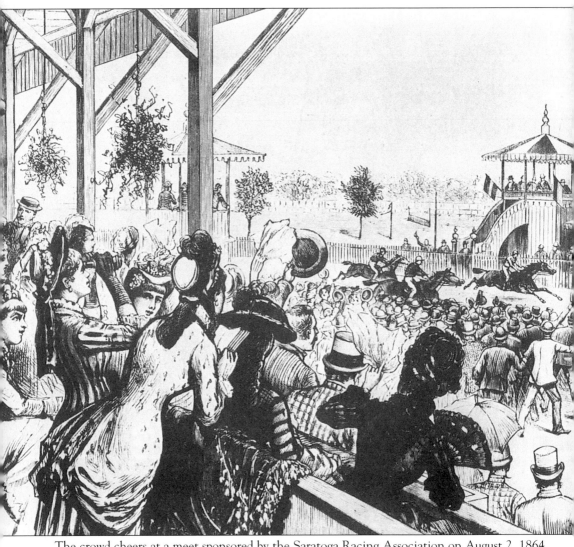

The crowd cheers at a meet sponsored by the Saratoga Racing Association on August 2, 1864.

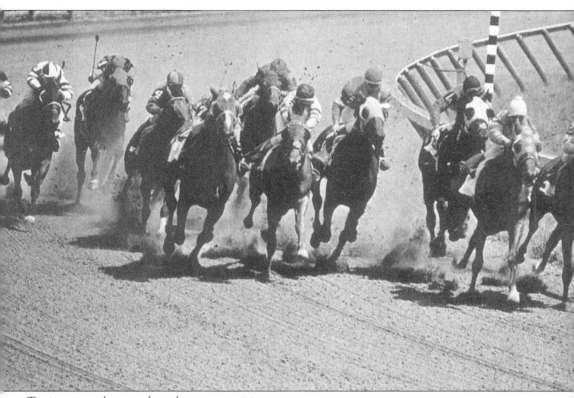

Turning into the stretch is always an exciting moment.

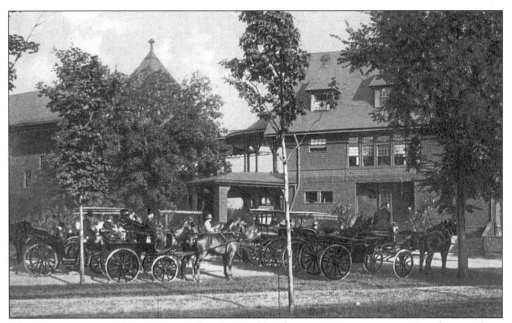

The August meet in Saratoga caps the thoroughbred summer racing season. It is known for a history of upsets in the great stakes races, the Whitney and Travers. Damon Runyon, habitué of the track and Broadway (Saratoga Springs as well as Broadway, New York), immortalized the characters he found here.

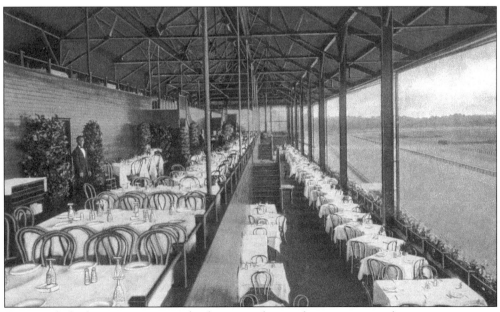

A particularly fine way to scout the horses is during the morning workout, over a piping fresh breakfast.

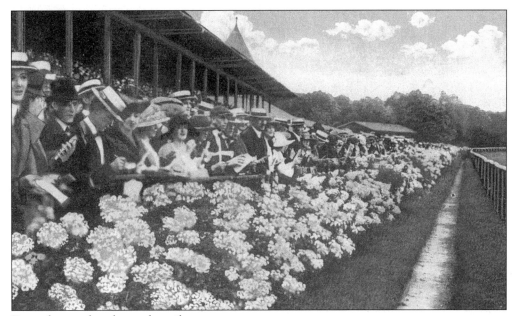

Every day was hat day at the rail.

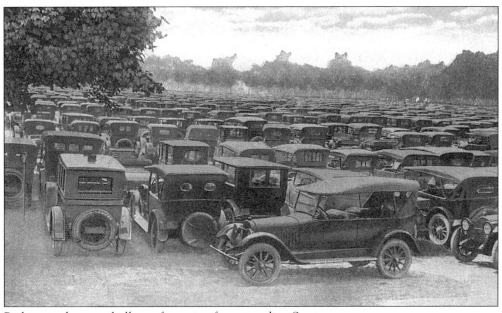

Parking is always a challenge for racing fans attending Saratoga.

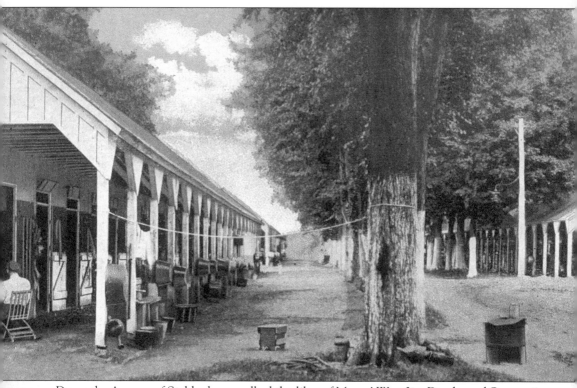

Down the Avenue of Stables have walked the likes of Man o' War, Jim Dandy, and Secretariat, on their way to greatness.

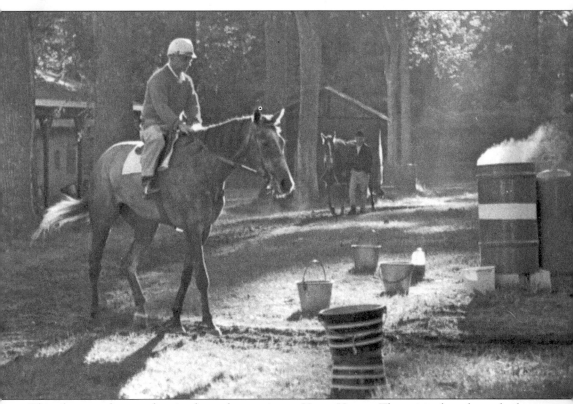

This photograph was taken in the early morning at Horse Haven. The original track was built by John Morrissey in 1863 and was later used as a training track.

A horse and rider ready themselves in the paddock.

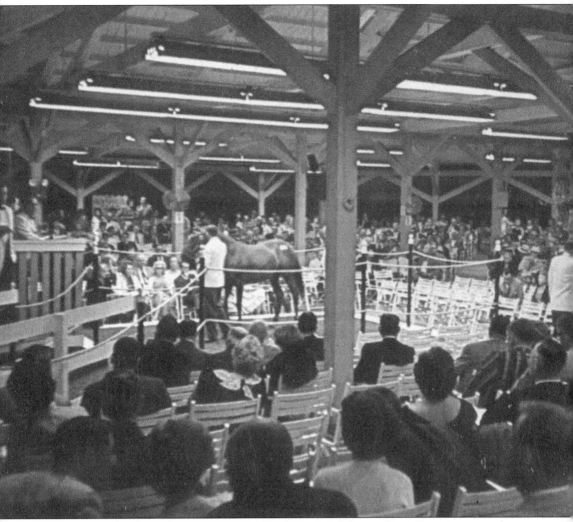

It all begins at the Fasig-Tipton auction, a block north of the track on East Avenue, where yearlings are picked to start their careers.

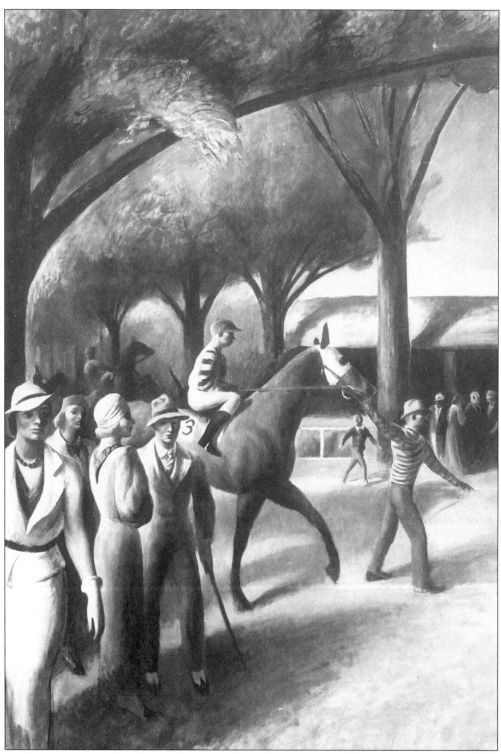

At the post office on Broadway, horse racing is confirmed as part of Saratoga's heart in this 1937 mural by Guy Pene du Bois.

Five

A CRADLE OF CULTURE

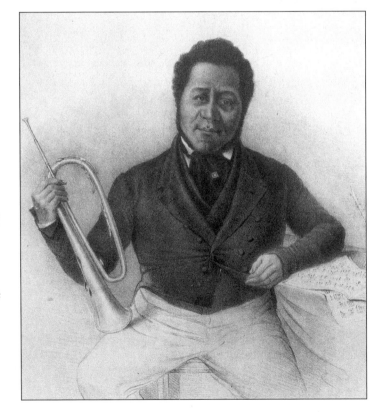

Francis Johnson (1792–1844) was one of America's first native-born master musicians. He came to the Springs in 1821, engaged at Congress Hall to preside over its plan of hops, balls, and concerts. He played morning and afternoon in Congress Park. Thus began early resort entertainment in America.

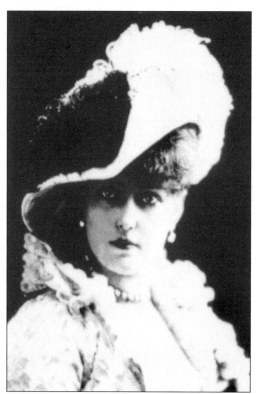

Lillian Russell first appeared at the Spa with Diamond Jim Brady in 1882; her appearances continued beyond 1900. A sought-after sight in her smart Victoria carriage drawn by two matching thoroughbreds, she also astonished observers of the scene by riding one of her many gifts from Diamond Jim: a gold-plated bicycle with handlebars bearing her initials spelled out in diamonds and emeralds.

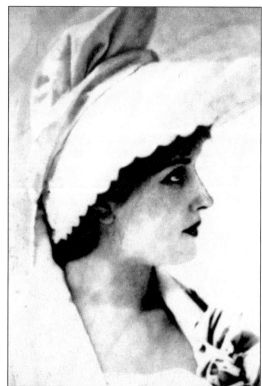

Lillian Russell was famous for the way she showed a hat.

Lillian Russell dined nightly at the Casino, where famed chef Jean Columbin prepared and often personally served her favorite dish: sweet corn with crepes suzette. Another gift from Diamond Jim Brady kept her in good canine company: a $2,000 diamond and gold collar for her Japanese spaniel, Mooksie.

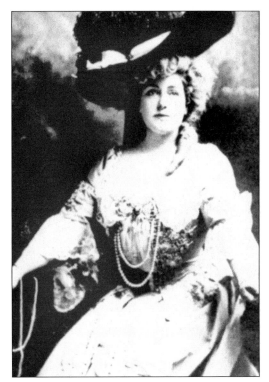

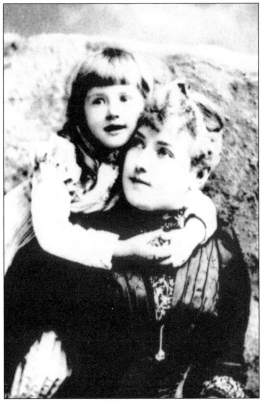

Here she is in a rare portrait shared with her daughter.

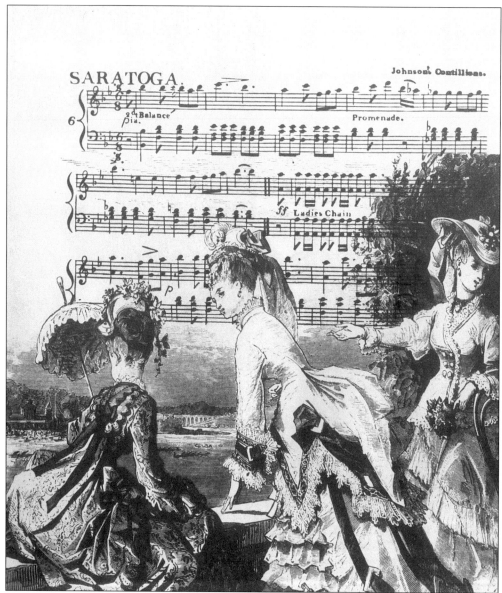

Johnson's piano piece "Saratoga" was a great hit at the Spa; along with his Grand Overture March, it was included with a set of *New Cotillions in Honor of the Illustrious General Lafayette*, which was introduced in October 1824 in Philadelphia on the general's return to America.

James Buchanan Brady justly deserved his nickname "Diamond Jim." He owned 30 sets of jewels, complete form collar studs to underwear buttons, more than 20,000 diamonds of all sizes and shapes, and 6,000 other precious stones. His fortune came from a great talent for selling railroad equipment, which put him in the company of the railroad magnates of the later 1800s. It brought him to Saratoga for the season, where his opulence and appetites inspired the attention and awe of the crowd.

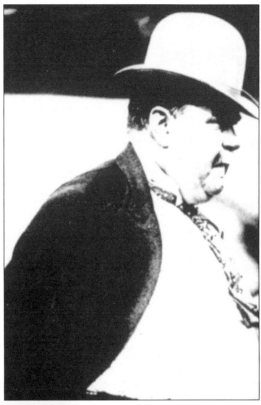

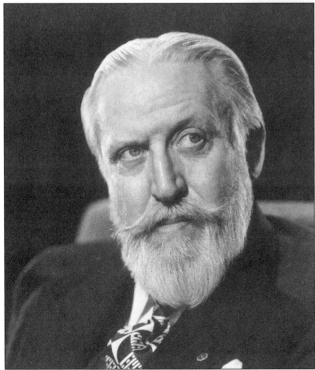

Monty Woolley, a Saratoga native who was an infamous theatrical character, became well known in Hollywood for *The Man Who Came to Dinner*. His father was a longtime proprietor of the Grand Union Hotel.

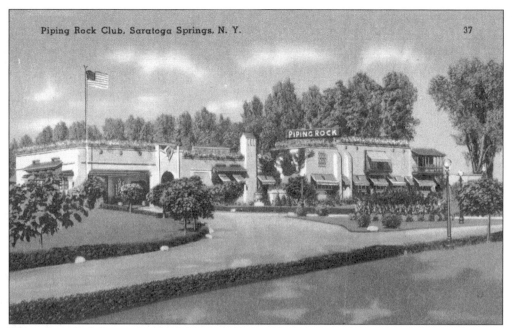

The culture and shape of nightclubs grew along with the automobile era. While gambling was not strictly legal throughout the state, the clubs found that the formula of headline entertainment and good, inexpensive food and drink brought the deep pockets. Piping Rock Club was on Union Avenue, on the way to the lake.

Sophie Tucker is shown at the Piping Rock Club.

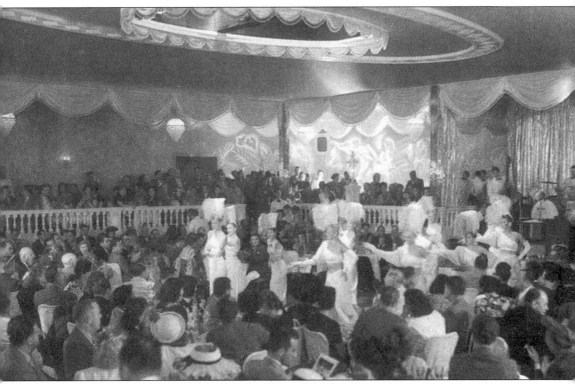

Many of the top entertainers were already in town for the season, showing up on stage or at a ringside table. Bing Crosby, Helen Morgan, Paul Whiteman, Jimmy Durante, and Gracie Field entertained. Cary Grant could be seen on the dance floor alongside a jockey who that day rode a stakes winner. The revue was a showstopper at the Piping Rock.

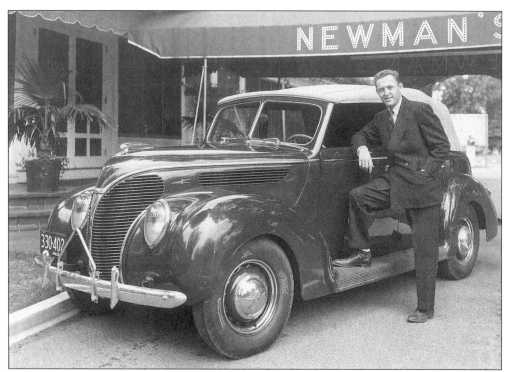

The lake houses were especially "hot." Norman Mendelsohn, a singer, stands in front of the popular Newman's Lakehouse *c.* 1938.

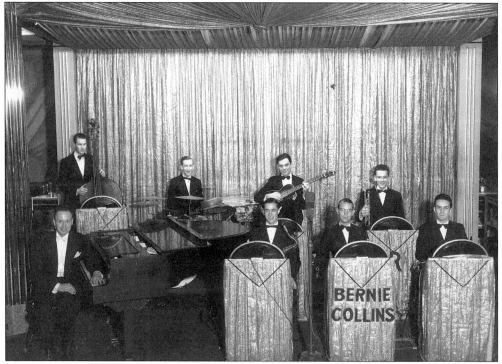

Bernie Collins, left, and his band appear at Riley's Lakehouse.

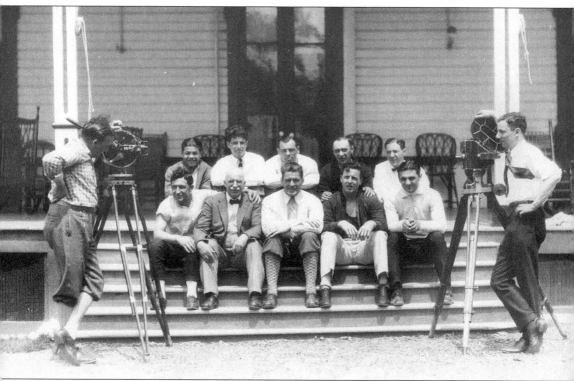

Jack Dempsey is seated third from the left in the front row at Luther's White Sulphur Springs in this 1920s photograph. Dempsey came to train for a his first heavyweight bout with Gene Tunney.

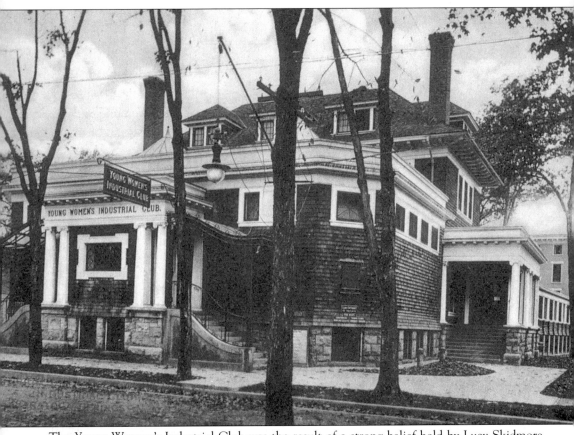

The Young Women's Industrial Club was the result of a strong belief held by Lucy Skidmore Scribner that women should be allowed to advance in liberal education and vocational interests. It started in the former parsonage of the Presbyterian church and began to grow within a few years.

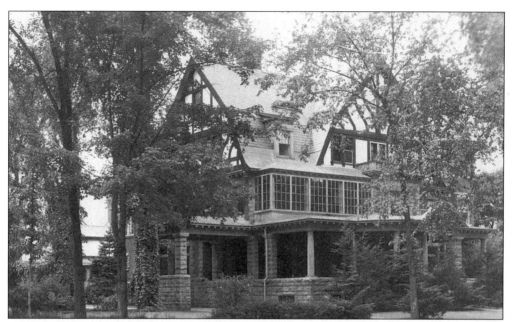

The institution was incorporated in 1922 under the name Skidmore College and expanded through various classic residences in the Union Avenue and Congress Park area.

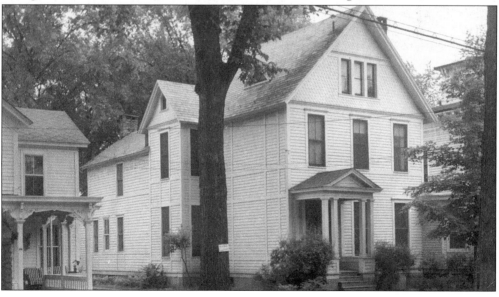

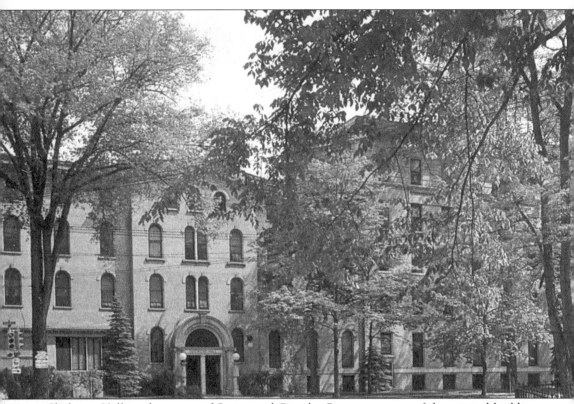

Skidmore Hall, at the corner of Spring and Circular Streets, was one of the original buildings of Skidmore College and was the touchstone of its service to the community. The degree of bachelor of science in nursing and health was authorized in 1922.

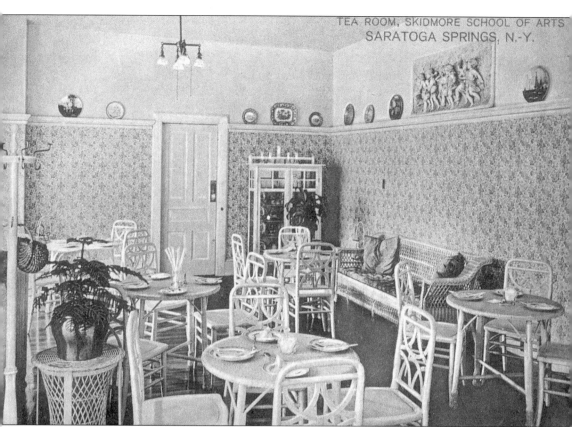

The Skidmore School of Arts, 1911–1922, was primarily a music conservatory with much personality. This is a view of the Tea Room.

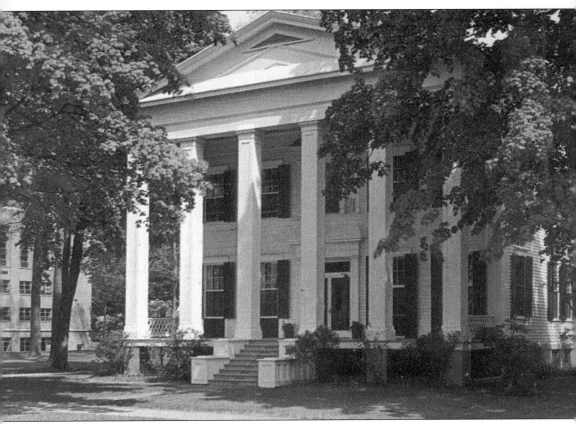

The president's house on Circular Street is shown at the time when Skidmore was in the Union Avenue area. The house was built originally for John Clarke, who made Congress Park a centerpiece for the town in the 19th century.

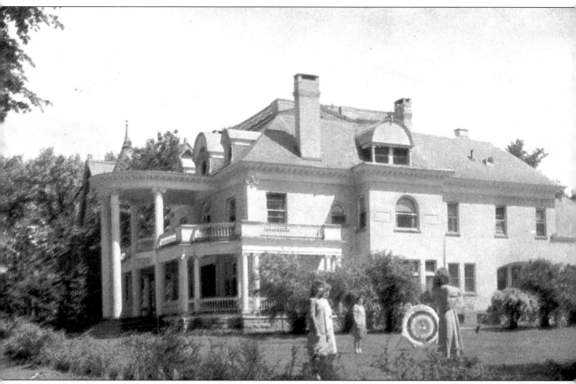

Some of the grand homes on Union Avenue were taken on as residences, an augury of Skidmore's burgeoning soon to come.

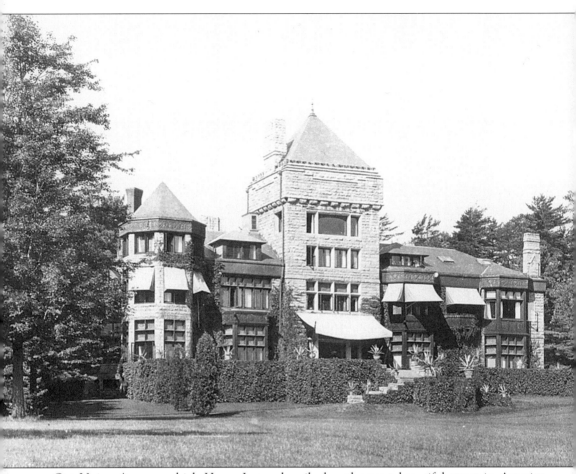

Out Union Avenue, which Henry James described as the most beautiful street in America, nestles a wellspring of unending creativity born of heartbreak. Spencer and Katrina Trask, enjoying a considerable degree of financial success, looked forward to a rich life on their large estate at the eastern edge of Saratoga Springs. They hosted elegant dinner parties and entertainments in the 1893 Victorian Gothic mansion. Then, in a short period, their four children died, leaving them broken in spirit.

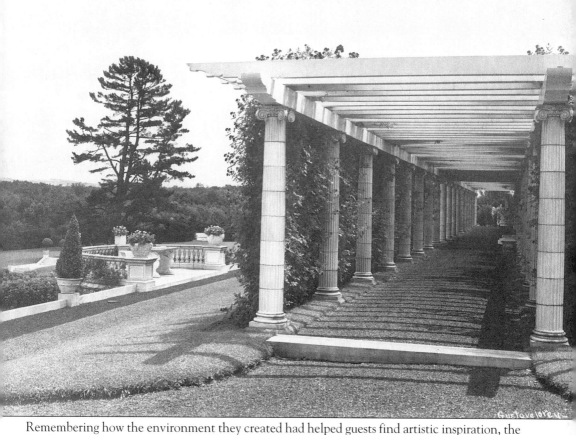

Remembering how the environment they created had helped guests find artistic inspiration, the Trasks began anew to contemplate how their home could best serve a living, creative purpose. They decided to turn their estate into a permanent retreat for working artists and to spend the rest of their lives improving it to this end.

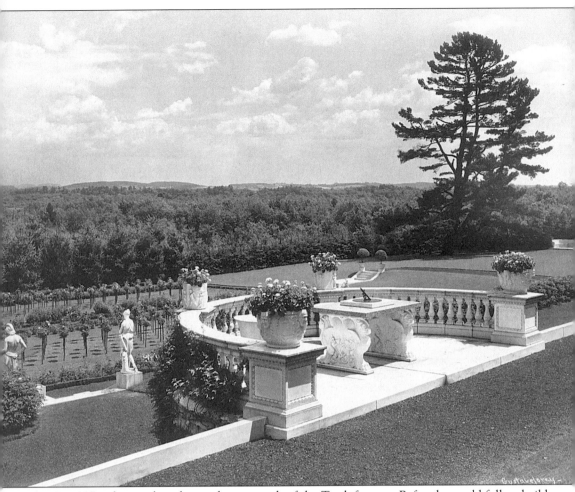

In 1907, a financial crash wiped away much of the Trask fortune. Before he could fully rebuild it, Spencer Trask was killed in a train wreck between Saratoga and New York City. Nevertheless, Katrina Trask continued to improve the property for its future purpose.

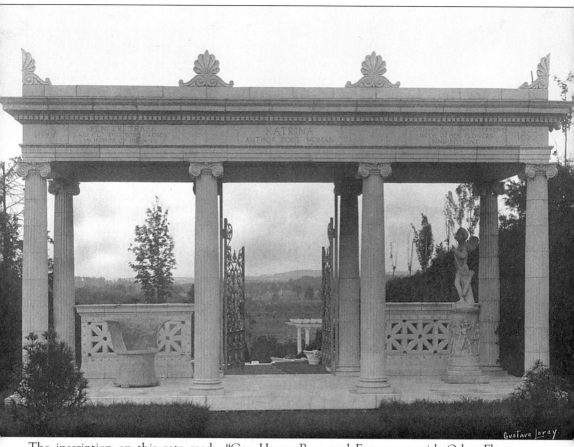

The inscription on this gate reads, "Goe Happy Rose and Enterwove with Other Flowers Bind My Love." Beyond the gate lie rose gardens, lovingly maintained by the citizens of Saratoga Springs.

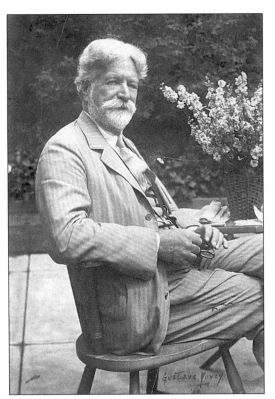

A lifelong friend of the family, George Foster Peabody had been Spencer Trask's banking partner and, earlier, his rival for Katrina's hand. Peabody stood by her through the difficult years, and they were married in 1921. She died the following year. He faithfully saw her wishes fulfilled, establishing the Corporation of Yaddo. In June 1926, the first group of gifted guests arrived.

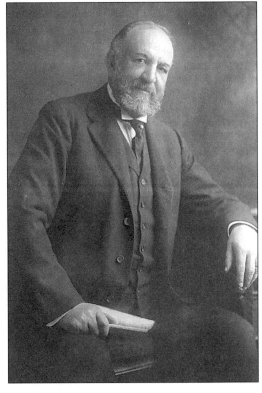

Shown is Spencer Trask. The area's legacy of artistic creativity has been continuous. Great names in music, the written word, sculpture, painting, and photography have been nurtured here. Among the many hundreds who have passed through are Aaron Copeland, Leonard Bernstein, John Cheever, Carson McCullers, Katherine Anne Porter, Langston Hughes, Kenneth Fearing, and Truman Capote.

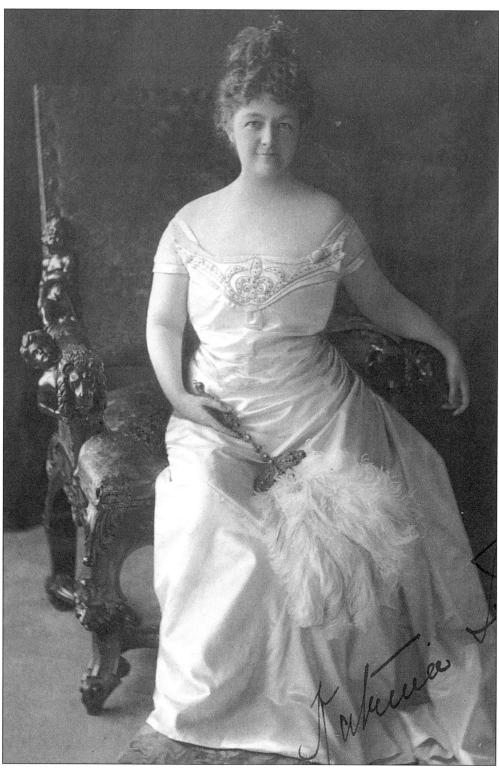

Katrina Trask was the shaper of Yaddo and the keeper of the dream.

John Cheever said, "The forty or so acres on which the principal buildings of Yaddo stand have seen more distinguished activity in the arts than any other piece of ground in the English-

speaking community or perhaps in the entire world."

The inscription on the sundial in Katrina Trask's garden, written in 1901, is as follows:

Time is

Too slow for those who wait
Too swift for those who fear
Too long for those who grieve
Too short for those who rejoice
But for those who Love Time is

Eternity